A GRAMMAR OF JAPANESE ORNAMENT AND DESIGN

BY THOMAS W. CUTLER, F.R.I.B.A.

PUBLISHED BY B.T. BATSFORD, 52, HIGH HOLBORN, LONDON.

Title page from original edition

A Grammar of
Japanese Ornament
and Design

Thomas W. Cutler

DOVER PUBLICATIONS, INC.
MINEOLA, NEW YORK

Bibliographical Note

This Dover edition, first published in 2003, is an unabridged republication of the work originally published in 1880 by B. T. Batsford, London. Color plates have been reproduced in black and white in this edition, and the Analysis plates have been moved to the beginning of the Analysis section.

Library of Congress Cataloging-in-Publication Data

Cutler, T.W.
 A grammar of Japanese ornament and design / Thomas W. Cutler.
 p. cm.
 "A republication of the work originally published in 1889 by B. T. Batsford, London."
 ISBN 0-486-42976-8 (pbk.)
 1. Decoration and ornament—Japan. 2. Decorative arts—Japan. I. Title.

NK1484.A1C87 2003
745.4'.0952—dc22

2003055668

Manufactured in the United States of America
Dover Publications, Inc., 31 East 2nd Street, Mineola, N.Y. 11501

THIS WORK

IS

(BY SPECIAL PERMISSION)

MOST RESPECTFULLY DEDICATED

TO

HER ROYAL HIGHNESS

THE PRINCESS LOUISE, MARCHIONESS OF LORNE,

BY

HER ROYAL HIGHNESS'S

OBEDIENT SERVANT,

THE AUTHOR.

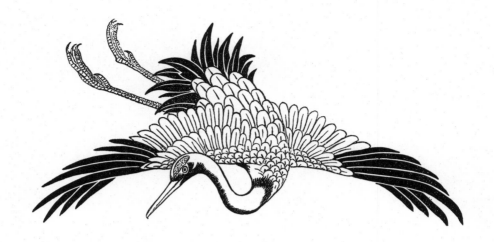

PREFACE.

————o∘⊱⋆⊰∘o————

IN this work, which I have ventured to call 'A Grammar of Japanese Ornament and Design,' my aim has been to present a carefully selected series of characteristic examples of the natural and conventional ornament of the Japanese which shall furnish a general and comprehensive view of the leading features of their Decorative work.

The absence of any such work, and my own ardent admiration for the Decorative Arts of Japan, resulting from eighteen years' pleasant study, led me to undertake this, which I hope will be of value to the Decorative Artist in whatever field he may be working, and of some interest to the Art-loving public. The subjects are all faithfully copied from the originals, and produced by the process most calculated to retain their spirit, all reductions having been made by photography.

In the introductory pages I have given a brief sketch of the History of the Japanese people, and of their industrial Arts, some knowledge of which is necessary to the proper appreciation and understanding of their Decorative work, which is strictly national in character. This is followed by a short examination of the chief elements and characteristics of their ornament, which, although conscious of its imperfections, I trust may be of some service in the effort to discover the spirit in which their work is conceived, and the method of its execution ; a subject of much interest to all lovers of their productions, and one which is yet far from being well understood.

I am indebted for much valuable information to various published works, notably M. Bousquet's 'Le Japon de nos jours,' Mr. F. O. Adams's 'History of Japan,' a paper on 'Pictorial Art in Japan,' read before the Asiatic Society of Japan by Mr. W. Anderson, various articles in the 'Japan Mail,' and Mr. A. W. Franks's 'Oriental Porcelain and Pottery'; I would also acknowledge my indebtedness to numerous friends, particularly Messrs. G. C. Pearson, W. Anderson, F. V. Dickins, and E. Dillon, who, from their long residence in the country, and intimate knowledge of the language, have been able to furnish me with reliable information upon many subjects.

I must record my special thanks to Mr. Bradley Batsford, not only for the care and anxiety he has shown to render the work in all its branches as satisfactory as possible, but also for the great assistance he has rendered to me.

For the shortcomings and imperfections in the text I have to crave indulgence, making no claim to literary ability, and the book having been compiled in the spare hours taken from professional work.

THOMAS W. CUTLER.

5 QUEEN SQUARE, W.C.,
 August 1880.

CONTENTS.

———o·o:⚬:o·o———

TITLE PAGES.

PAGE

DEDICATION iii

PREFACE v

LIST AND DESCRIPTION OF PLATES ix

INTRODUCTION 1

 ARCHITECTURE 7

 SCULPTURE 9

 PAINTING 11

 LACQUER 13

 CERAMICS 16

 TEXTILE FABRICS 18

 METAL WORK 19

 ENAMEL 20

 DECORATIVE ART 21

ANALYSIS 26

 PLATES TO DITTO, A—G.

PLATES NUMBERED I. TO LVIII.

LIST AND DESCRIPTION OF PLATES.

———∘∘⦂⦂⦂∘∘———

ANALYSIS.

Plate A, Geometrical.
 ,, B, Curvilinear.

Plate C, Bamboo.
 ,, D, Orchid.
 ,, E, Flowers.

Plate F, Birds.
 ,, G, Water.

BIRDS.

PLATE

I.—Cranes. Fig. 1 from Hokusai's *Mangua*; Fig. 2, from Hokusai's ' Hundred Views of Fuji'; Fig. 3, from a lacquered tray, cranes in gold, legs and tails black, on red ground.

II.—Jay. Fac-simile of original drawing.

III.—Kingfishers. Figs. 1, 2, and 3, from drawing-book. Figs. 4, 5, and 6, from original drawing.

IV.—Cranes. From carved bamboo, quarter size of original.

V.—Falcons and Hawks. From Hokusai's *Mangua*.

VI.—Cranes in Clouds. From embroidery. Cranes white; neck markings, tails and legs, black; red-capped heads; clouds in gold.

VII.—Small Birds. Common to Japan.

VIII.—Swallow and Willow. Fac-simile of original drawing.

IX.—Wild Geese and Ducks. Fig. 1, from Hokusai's *Mangua*; Fig. 2, from Hokusai's ' Hundred Views of Fuji.'

X.—Japanese Bantams and Game Fowls. From Hokusai, and coloured drawing.

XI.—Pheasants, Quails, Etc. Upper part of plate from Hokusai's *Mangua*; lower part from coloured drawing-book.

XII.—Group of Cranes. From old embroidery; coloured as original, quarter full size; original worked in silks and gold, on satin ground.

FISHES.

XIII.—Carp Swimming up and down Stream. From lacquered bowls. Fish and water in various shades of gold, on red ground.

XIV.—Carp. From painting on silk gauze, half-size of original.

XV.—Various Fish. From painting on silk gauze, half-size of original.

XVI.—Dead Carp Strung on Bamboo. From embroidery; original colours; body of fish, grey; head and markings of scales, black; bamboo leaves in two shades of green, stem and tie in gold thread.

XVII.—Carp. Fac-simile of kakemono.

XVIII.—Fish and Water. From old embroidery, quarter full size.

INSECTS, ETC.

PLATE

XIX.—Insects, Etc. From various drawing-books; Fig. 1, lady-bird; 2, cricket; 3, humble-bee; 5, lizard; 6, wasp; 7, dragon-flies; 8, grasshopper.

XX.—Procession of Insects from Kakemono. The drawing depicts a procession of grasshoppers, wasps, and other insects: they carry a cage in which is a beetle, and various grasses and flowers as insignia, also cones, etc., as baggage; a mantis beetle is ridden as a horse, and insects walk in front to clear the way. The drawing is a caricature of a *Daimio's* procession.

XXI.—Frog, Crabs, and Prawn, in upper part of plate, are copied from original drawings. The Dragon, in lower part, from a cloisonné enamel dish.

XXII.—Bats. From old embroidery. Chickens and Insects.—From original drawing.

FLOWERS, PLANTS, TREES, ETC.

XXIII.—Flowering Shrub (*Lespedeza*). From lacquer, gold leaves and stem, red flowers, on black ground.

XXIV.—Chrysanthemum (conventional). From embroidery, leaves and stems in various shades of green, flowers from pale salmon to deep red, fan cord and tassels in gold.

XXV.—Cherry Blossoms. From old lacquer, flowers, and leaves in different coloured gold, on black ground.

XXVI.—Sea Pinks, upper part of plate. From old lacquer; flowers in shades of gold, silver, and red; leaves gold, on aventurine ground. Lower part: branches of cherry tree. From old lacquer; flowers and leaves in three shades of gold, on aventurine ground.

XXVII.—Birds and Flowers from Kakemono. Original; yellow and pink chrysanthemums, leaves and stems grey-green; flowering grass in shades of red, bird brown.

XXVIII.—Peony, upper part of plate, from old lacquer; flowers, leaves, and stem in three shades of gold, on black ground. Wild Plum; on lower part, ditto ditto.

XXIX.—Wisteria (conventional), upper part of plate, from original drawing in Indian ink. Water-lily (conventional), lower part, from blue and white porcelain.

XXX.—Bamboo and Plum. From lacquer, trees in gold, on black ground.

XXXI.—Cherry. Upper part of plate, from original drawing, leaves in shades of brown, flowers white, on brown-yellow ground. Lower part from embroidery; stem and leaves in various shades of green, flowers white, with pink stamens, and pink and red, with white stamens, on black ground.

XXXII.—Plum Tree. From old embroidery, stem and bamboo in green, buds in white, flowers in gold, on dark-blue ground.

XXXIII.—Various Studies of Trees. From Hokusai's *Mangua*.

XXXIV.—Various Flowers. From Hokusai's *Mangua*.

XXXV.—Groups of Iris growing in Water, with Staging in a Native Garden. Fac-simile of old lacquered tray.

XXXVI.—Various Flowers. From drawing-book.

XXXVII.—Studies of Bamboo, Grasses, Etc. From Hokusai's *Mangua*.

XXXVIII.—Lespedeza, Fern and Grass. From old lacquer, the foliage, etc., in various shades of gold, on black ground.

XXXIX.—Bamboo, Fir, Wild Cherry, and Crane—emblematic of longevity. From old lacquer. Trees, etc., in gold, on black ground.

XL.—Various Flowers. From drawing-books.

XLI.—Decorations for Sword Guards. From drawing-book by Isai, pupil of Hokusai.

XLII.—Bamboo, Pine, Plum, and China Rose, enclosed with bamboo railing. From old lacquer. Foliage in gold, on black ground.

XLIII.—Barley, Millet, Vetch, and Thistle. From Hokusai's *Mangua*.

XLIV.—Flowers (conventional). From lacquer. Flowers, leaves, and stem in three golds, on black ground.

ORNAMENT.

PLATE

XLV.—Various badges of the nobility and gentry, which constitute the native heraldry.

XLVI.—Four designs from silk brocades.

XLVII.—Medallions of flowers on fret diaper, upper part of plate. From lacquer. Flowers in silver, leaves, stem, and fret in two shades of gold, lacquered on natural wood of rich brown colour. Centre design from Kiôto pottery, lower part of plate. Small medallion in centre, from an original drawing in Indian ink; subject, kylin and peony. Two outer circles, designs for sword guards, by Isai.

XLVIII.—PLUM AND SNOW-LADEN FIR. From printed and embroidered crêpe.

XLIX.—CHRYSANTHEMUM (conventional) in circle. BAMBOO AND PLUM in panel. PEONY (conventional) in panels. From lacquer. In shades of gold, on black ground.

L.—CHRYSANTHEMUM, BAMBOO, AND CONVENTIONAL WATER. From printed and embroidered crêpe.

LI.—Various heraldic badges.

LII.—Ditto ditto.

LIII.—Various designs worked in lacquer. From " markers " and boxes. Ornament in two shades of gold, on brown and black ground.

LIV.—Various heraldic badges.

LV.—PEONY (conventional). From embroidery.

LVI.—CHERRY FLOWERS (conventional), upper part of plate. From old wall paper. Flowers in black and gold, on silver ground, fret in two shades of silver. CHRYSANTHEMUM (conventional), lower part from old wall paper. Flowers and leaves in gold, on green ground.

LVII.—Four designs from silk brocades.

LVIII.—Four designs from wall papers and silk brocades.

WOODCUT ILLUSTRATIONS.

(ENGRAVED BY MR. W. H. HOOPER.)

CRANE FLYING ACROSS THE SUN	Title page.
FLYING CRANE	Preface.
THE KIKU MON } The Badges of the Mikado	Page vi.
THE KIRI MON }	„ vii.
LOBSTER	„ 6
FLYING BAT	„ 25
CONVENTIALIZED CRANE	„ 38

A GRAMMAR

OF

JAPANESE ORNAMENT AND DESIGN.

INTRODUCTION.

THE great difficulties attending any attempt to explore, still less to explain, the art thoughts and methods of a people who for centuries kept themselves aloof from all foreign intercourse, and their country jealously closed against strangers, can be readily appreciated by those who have studied the artistic industries of Japan. At various periods within the last three centuries some slight insight into the subject has been obtained, but the natural reticence of the Japanese, added to their dislike for foreigners generally, has made it impossible that anything like a comprehensive knowledge should be gained. The writers to whom we are indebted for our earliest knowledge of Japan give us little information with regard to its art, and it is only since the opening of the country within the last twenty years, that a few foreigners have sufficiently mastered the difficulties of the language to enable them to commence a study of the art methods and principles. Although in two or three recent works many valuable investigations have been entered upon, there is still much to be learned before the theory and practice of Japanese art can be satisfactorily explained.

The magnificent collection brought to England for the Exhibition of 1862, by Sir Rutherford Alcock, K.C.B., then H.B.M. Minister to Japan, first gave the outside world an insight into the decorative arts of this interesting country; and aroused that enthusiasm for its productions which has exercised so great an influence on European decorative art, and awakened the desire in art circles to explore the fresh field of inquiry thus thrown open. In order to understand the conditions which have tended to form the strictly national character of Japanese art, it is desirable to pass in review some of the leading features of the history and institutions of the country, and the author hopes that the following pages, written after careful study of the leading authorities, and supplemented by the assistance of friends now in England, whose long residence in Japan renders their information of great value, will interest, and afford some aid in the study of the subject.

Although intercourse has existed between Corea, China, and Japan for the last thirteen centuries, it was not until the sixteenth that Europeans set their foot in the country, when some Portuguese adventurers sought shelter upon an unknown coast, which proved to be Japan. The earliest European writers from whom we obtain any valuable knowledge of the country are, first, Kaempfer, then Thunberg, and lastly Siebold, all of whom were medical

European Intercourse.

men attached to the Dutch factory, which appears to have been established early in the seventeenth century at Déshima, a small island communicating with the port of Nagasaki by a bridge; they wrote at intervals of half a century from each other, and gained no insight into the country except during a journey made annually to Yedo, the capital, to pay their respects to the Shôgun, and then their only chance of observation was through the windows of their well-guarded *norimons* (a kind of carriage resembling a palanquin).

In July 1853, the U.S. squadron, under Commodore Perry, arrived at Uraga with a letter from the President to conclude a treaty, which was signed in 1854. In 1857, Admiral Pontaitine made a treaty on behalf of Russia; in August 1858, Lord Elgin, as H.M. Ambassador, signed the first treaty on behalf of England, and in October in the same year the treaty with France was concluded. In July 1859, Mr. Alcock (now Sir Rutherford) arrived at Yedo as H.M. Minister. Notwithstanding that treaties were signed and diplomatic negotiations entered into with many foreign Powers, their official representatives had great difficulty in getting the conditions carried out, and were not allowed to travel out of the district assigned to them, without special passes. The native jealousy of foreigners resulted in many murders, and two attacks were made upon the British Legation, when Sir Rutherford Alcock and officials narrowly escaped assassination. During the years 1862–3–4 frequent conspiracies were organized, and great pressure put upon the Mikado to induce him to order the expulsion of foreigners, and it was not until armed force had been used against the insurgents that security was enforced, and the country was really opened to European intercourse.

Origin of People.　　The origin of the Japanese people is still involved in mystery; that they are a mixed race is clear; there is Chinese, Mongolian, and Corean blood amongst them, also Malay, and there may have been immigrations from the Polynesian Islands. It has not been determined with any degree of certainty whence the invaders came who dispossessed the aborigines, known as the *Aino*, and now only to be seen in the northern island of Yezo. They are a hairy race, living in poverty in the rudest huts, and speaking a language of their own. Dr. Dickson says: " There are two strongly-marked varieties of features in Japan, which are always strikingly portrayed in their own pictures; there is the broad flat face of the lower classes, and the high nose and oval face of the higher. The difference is so marked as to be some argument in favour of a previous mixing of two different races : the one which had extended southwards from the Kurile Islands and Siberia, hairy and broad-featured; the other which had originated from the south, with Indian features and smooth skins."

With respect to the invaders, Japanese tradition states that the fifth ruler in descent from the Sun-goddess was Jimmu, or the spirit of war (B.C. 667). He is said to have been the first *mortal* ruler. It is very probable that this hero, or his ancestors, came originally from the main-land of Asia with a body of adherents; that these men landed in the southern island of Kiushiu, established themselves there, gradually vanquished other tribes of immigrants, and, pushing their conquests farther and farther, drove the aborigines to the northward and eastward, and thus Kiôto or the capital (which is the signification of the word), came to be established in the largest of the group. It is in the nature of events that many of the aborigines would remain attached to the soil which they and their fathers had cultivated, and would become the bondsmen of the invaders. From them, with an admixture of the intruders, it may be assumed that the flat-faced peasants and lower classes of the present day are descended, while out of the ranks of the invaders exclusively was formed that military class which became dominant, and constituted the nobility of the land. The generals and chiefs of tribes, and the whole military caste,

naturally lorded it over the peasants, and despised them; whilst the latter looked up to and were subservient to the former. It is thus easy to conceive that after a time the chieftains would come to be regarded as so much above the common people that the fiction of divine descent was attributed to the ruler, and that the Japanese mythology was invented to support this pretension.

The Mikado.

It is well known that according to Japanese tradition the present Mikado or Emperor is descended from the Sun-goddess, without a single break for 10,000 years. This presumption is to be found continually in Japanese writings, and in edicts promulgated by the Mikados. Many statements have been made concerning the origin of the word Mikado; one derivation is from *mi*, honourable, and *kado*, gate, which conveys the idea that the Emperor is so far above the rest of mortals, that it would be disrespectful to speak of him directly— just as none but the privileged few were allowed to enter his presence—and therefore he is designated by the gate of his palace; but Mr. Satow states that there is a different etymology, which he thinks harmonizes better with Japanese ideas, viz. *mika*, great, and *to*, which, according to the euphonious rules of the language, becomes *do* in composition, and is a root meaning "place."

After the sovereign power had been established for a number of years at Kiôto, the members of the Imperial family had considerably increased, and they formed a class by themselves. These are the *Kugés*, or court nobles, so often mentioned in contradistinction to the *Daimios*, or territorial nobles. They all, of course, claimed divine descent, and occupied the highest offices about the court.

Government, grades of nobility and people.

The form of government established by the earlier Mikados was a pure despotism. Penal laws, imperial edicts, and administrative regulations, were all supposed to emanate from the sovereign. From about the twelfth century, however, owing to internal and external commotions, the actual duty of repressing tumults and executing justice upon rebellious subjects was entrusted to a generalissimo of the Imperial forces, known as the *Shôgun*. (In the early treaties and diplomatic correspondence he is, under a misconception, called *Tycoon*.) In the beginning of the seventeenth century this office fell into the hands of a member of the Tokugawa family, in which it became hereditary, and so continued down to 1867, when the incumbent resigned the office into the hands of the Mikado. During this period of the Tokugawa power, lasting more than 250 years, the entire executive authority of the government was exercised by the Shôgun. He did not, however, assume independent sovereign power, but continued to act nominally as the representative and servant of the Mikado. It was during this period that the feudal system attained its highest development in Japan. The ancient territorial nobles, who were formerly almost independent sovereigns in their territories, were reduced to subjection, and became vassal princes under the Shôgun. New and conquered provinces were parcelled out to the connections of the Shôgun's family; so that, at the time of the making of the foreign treaties, there were about 200 of these princes, who, under the name of *Daimios*, exercised local authority in their provinces, and yielded feudal obedience to the Shôgun, as their superior lord.

Beside the eighteen principal or *kokushiu Daimios*, there were two classes of princes, the one existing before Iyéyasu's era, and called *tozama*, or "outside nobility," and the other composed of his own adherents, and called *fudai*, or "vassals of the dynasty." Next to the prince and his family came the *karos*, or "elders." Next to the *Daimiô* (great name), but as *Shomiô* (small name), inferior to them in rank, were the *hatamotos* (under the flag). These were, as the name implies, men who rallied round the standard of the Shôgun in war time.

In many instances the *hatamoto* were branches of the oldest and most illustrious families of the empire. The *gokénin* though superior in numbers, were a much inferior body to the *hatamoto*, both in rank and income. These two large bodies of the military class, forming the hereditary personal following of the Shôguns, and numbering, with their families and dependents, certainly not less than half a million of souls, were supported from generation to generation by the incomes assigned to them, in lands or in rice, out of the property of their lord. Below the classes already mentioned were the great bulk of the *samurai*, the "two-sworded" military retainers. They were reckless, idle fellows, acknowledging no obedience but to their lord, for whom they were ready at any moment to lay down their lives, either on the field of battle, in defending him from assassination, or (whether at his order, or of their own free will) by suicide, to save themselves and their families from what, according to the strict code of Japan, was deemed dishonour. The classes below them they treated with the utmost contempt and brutality, and it is obvious that permanent harm was done to the country by this large unproductive class, and that Japan remained poor in consequence.

The rest of the population was divided into three principal classes, in the following order : farmers, artisans, and merchants. There were also two sets of people below these in the social scale, the *eta* and the *hinin*. The *eta* were a class of outcasts, living in separate villages or settlements apart from the general population, with whom they were not allowed to inter-marry. Their means of livelihood consisted in working skins, and converting them into leather, which was considered a degrading occupation. Working in *prepared* leather was not so considered, it was the *handling of the raw hides* which was deemed to be such. Some accounts state these people to be the descendants of foreign immigrants. The *hinin* (or "not humans") were a class of paupers, who only came into existence after the commencement of the Tokugawa dynasty of Shôguns. They were allowed to squat on waste lands, and to build huts for themselves. They gained a livelihood by begging, and were employed to carry away the dead bodies from the execution grounds. They were not allowed to intermarry with the ordinary people. It was however possible for a *hinin*, by industry, to raise himself from this degraded condition, although instances were rare.

In June 1871, a proclamation was issued permitting all ranks to ride on horseback, a privilege hitherto jealously monopolized by the upper classes ; in July permission was given to the people to wear the *hakama* and *haori*, the distinctive garments of the *samurai* ; and finally, in November, permission was given to nobles to take their wives and families abroad. The privileges of citizenship were given to the hitherto proscribed *eta* class, and removed from them the ban which they had laboured under for centuries. Provision was made at the same time for the *hinin* class (mendicants, leprous persons, etc.), and the number of destitute, and at times loathsome-looking objects who infested alike the streets of Yedo and Yokohama, have been removed to places where they are fed and employed as far as circum-stances permit.

Religion.

The early religion of Japan was *Shintôism*, or the worship of the powers of Nature, the latest development of which has been preserved in a work on Sin To, by a learned Japanese woman of the twelfth century. The Shintô idea of creation is that out of chaos the earth was the sediment precipitated, the heavens the ethereal essences which ascended, and that man appeared between the two. The first man was called Kuni-toko-tatchi-no-mikoto. Jimmu Tenno, the son of Fukia-wasezu-no-mikoto, was the first Mikado (B.C. 667), and from the date of his accession the Japanese *ki gen* commences. The present Mikado is the 123rd of the line. In the sixth century, Buddhism, which had been introduced into China from Corea some four centuries earlier, was carried into Japan, and was disseminated rapidly

by means of the Chinese literature which the priests received. In the thirteenth century a monk named Sin Ran founded a new Buddhist sect, which incorporated in its belief much of the old creed. In the sixteenth century the Christian faith was introduced by the Portuguese, led by the Jesuit Father, Francis Xavier, and spread rapidly for about forty years, but in 1587 the Catholic missionaries were exiled, and the religion proscribed. The always powerful Shintô and Buddha creeds again held sway, and continued to do so up to recent times.

Few subjects are more interesting than the artistic temperament of the Japanese. The full development of their genius is so obvious that no one can doubt it has reached its highest perfection, and it is equally certain that this development has been arrived at by slow and gradual steps.

Art.

It is proved beyond question that the earliest art in Japan came from China, in the fifth century; and from that time until the twelfth the Japanese showed but little aptitude as pupils. In the thirteenth was founded the *Yamato*, or Japanese school, and this commenced an epoch marked by considerable progress in execution, although showing as yet no evidence of originality or creative power; nothing in fact but a slavish imitation of Chinese models. This period of progress appears to have lasted until the early part of the fifteenth century, when was founded the *Kano* School, which with the *Tosa* (followers of the *Yamato* School), exists in a modified form in the present day. From the middle of the fifteenth century until the commencement of the eighteenth would seem to have been a period during which but little advance was made; but towards the close of this century some attempt was made by a few artists to free themselves from the trammels of Chinese models, retaining their processes and science whilst endeavouring to found an original style, and taking their subjects from nature, and national and popular sources. Still it must be borne in mind that these men belonged to the nobility, and it remained for Hokusai and his followers—men of the people—who appeared at the commencement of the present century, to popularize art in Japan, and to produce the most truly characteristic art their country has seen. From the earliest times, and throughout the middle ages, and indeed down to the advent of these men, art had been practised only by the nobles, and chiefly by them as a pastime. It sometimes happened at the ancient court of Kiôto, that some "*Kugés*," reduced by indigence to labour for their livelihood, betook themselves to liberal careers, becoming chiefly professors of music, masters-of-arms, etc., and sometimes devoting themselves to pictorial or decorative art; but with the advent of Hokusai and his school, a new order of things was introduced, and these arts, which had languished with more or less feebleness for many centuries in the hands of the "two-sworded" amateurs, now began to show signs of surprising vitality and freshness, nurtured by these humbler workers, who, requiring but little for their subsistence, expended their skill upon the cheapest and simplest objects.

During the long period in which the Japanese jealously secluded themselves from all contact with the European world (whose advice and example they have now too great a tendency to follow without discrimination) they tempered all the outward magnificence of life with a simplicity which is ever perceptible in their manners, while they remain genuinely national. Before these estimable qualities were degenerated by a too close intimacy with European ideas, they were able in every way to prove themselves inimitable in the interior arrangement of their habitations, in the harmony of colours, and in the choice of decoration. A Japanese house exhibited in its simple apartments, a refinement and simplicity in marked contrast to that discordant style which is so offensive to the eye in most of our European rooms. Give some flowers to a gardener, or to a young girl, and they will intuitively form

them into a bouquet, without symmetry, which shall possess the originality of an inspiration. It is in this manner that the Japanese bear the palm from the Chinese, supplying, by natural taste, the elegance and imagination which their prosaic masters lack.

Calligraphy.

Calligraphy in Japan, as in China, holds a position at least equal to that of painting, and this has without doubt greatly conduced to the artistic power of the people. The school-life of the "*samurai*" boy begins when he is about six years of age. His first task is to copy, in weary routine, the Japanese letters. He uses at first a brush as large as one's little finger, so that every defect of his execution would be plainly manifest. The master sits by him and directs his movements. Every one of the complicated letters is required to be made with the strokes in the same order, and with the same emphasis. As the cost of the paper is a serious burden, he is required to use the same sheets many times over; the letters of one day are smeared out at its close, and the papers dried in the sun for the next. As you pass along the streets of a Japanese town, you may see the schoolboy's copy-book hung out to dry, and the schoolboy himself you can always detect in his homeward march from school by his smudged fingers and face, which have received more than their share of the writer's ink. At the lowest estimate, a schoolboy is required to learn one thousand different characters. In the government elementary schools about three thousand characters are taught. A man laying any claim to scholarship knows eight or ten thousand characters; and those who pass for men of great learning are expected to be acquainted with some tens of thousands. It is noticeable that the Japanese word *kahu* has, like the Greek γραφειν, the double signification of writing and painting. We have no record of the introduction or manufacture of paper until about A.D. 610, but it is probable that it was known many centuries before, and was used when the art of writing was first introduced.

The Japanese pencil is called *fumute*, or *fude*, the latter name being most commonly used. Pencils were at first made by Chinese immigrants. About the period of Taiko (A.D. 701–703), ten pencil-makers began to be employed in the "Board of books and writings," in manufacturing pencils for use there. These pencils were made of the hairs of rabbits, badgers, deer, and of other materials.

ARCHITECTURE.

JAPANESE architecture is an architecture of wood, a material which does not convey the idea of grandeur or duration. Although the Japanese have used stone for many centuries, for their castle moats, boundary walls, and the bases or foundations of their buildings, yet they have not made any progress in its adaptation. This is to be accounted for by the liability of the country to earthquakes, which occur so frequently that scarcely a month passes without some shocks of greater or less force being felt. This has dwarfed their buildings, from the temple and palace, to the peasant's hut, and induced them to make use of the most perishable of materials. Thus Japanese architecture is under immense disadvantage when put in comparison with European. Architecture as understood in Europe cannot be said to exist in Japan; it is but artistic carpentry, decoration, and gardening. The Japanese know the science of building, but not the art. The framing of their buildings is very clever carpentry, designed to meet the sudden shocks to which their buildings are always liable, the timbers being cleverly dovetailed and keyed together, so that if they are shaken out of an upright position they can be pushed back again, and wedged up into their original perpendicular state.

The Japanese doubtless obtained their first ideas of architecture, like the sister arts, sculpture and painting, from China, and the Buddhist religion brought with it from India many native characteristics and details. Without going deeply into the subject, we may notice one particular feature which is purely Indian, namely the *tori-i*, which corresponds with the *toran* of India: again, in their carvings the elephant and tiger, which do not exist in Japan, are frequently depicted. The *tori-i* was originally a perch for fowls offered up to the gods, not as food, but to give warning of daybreak, and it was erected on any side of the temple indifferently. In later times, its original meaning being forgotten, it was placed in front only, and supposed to be a gateway. Japanese antiquarians tell us that in early times, before carpenters' tools had been invented, the dwellings of the people who inhabited these islands were constructed of young trees with the bark on, fastened together with ropes made of the rush *sugé* (*Scripus maritimus*), or perhaps with tough shoots of the Wisteria (*fuji*), and thatched with the grass called *kaya*. In modern buildings the upright posts of a house stand upon large stones laid on the surface of the earth, but this precaution against decay had not occurred to the ancients, who simply planted their posts in holes dug in the ground.

Architecture in Japan, considered as an art, dates from the first temple. In the ages of faith, man thought of the houses of the gods before decorating his own habitation, and it is to the temples of Shintô and Buddha one must first look, then to the burial-places and shrines of the Mikados and Shôguns, and next to the *yashikis* (palaces) of the Mikados and nobles. The temples and burial-places still remain, but the *yashikis* are things of the past, and since 1870 are either dismantled and in ruins, or, despoiled of all their beauty and grandeur, are occupied by traders, or used as barracks for the soldiers.

All the temples in Japan are composed of two types, the Shintôist and the Buddhist. The principal of these are to be found in Isé, Nikko, Osaka, Kiôto, and Tôkiô (or Yedo). The two principal groups in Yedo, are at Uyeno and Shiba; unfortunately at both these

places the large central temple has been destroyed by fire. The subsidiary temples, however, are so numerous and imposing that these sites still rank first in importance in the city as temple groups. The Uyeno and Shiba temples may be said to have belonged to the Shôguns. It was under their direction that they were built, and that the vast sums required for their erection were provided. The shrines of the 1st and 3rd Shôgun, both eminently illustrious in Japanese history, are at Nikko, those of the 2nd, 6th, 7th, 9th, 12th, and 14th at Shiba in Yedo, and the others at Uyeno.

The pure Shintô temple was built of unpainted, unlacquered wood, even to the roof, and the interior was decorated in monochrome. One recently built by the present Mikado, at Yokohama, is described as of the purest grained cedar (*shinoke*), the workmanship is of the highest finish, but perfectly plain without any ornament, the roof shingled with cedar shingles beautifully laid, and the interior free from decoration. The Buddhist temple was constructed with coloured posts and framework, with the highly curved semi-gabled roofs covered with rich tiles and copper, the ends of principal timbers and feet of posts shod with bronze richly chased and gilt, and the carving and ornament to the exterior and interior highly decorated.

While wanting sublimity and religious grandeur of conception, the Japanese have a profound and exquisite taste for nature, which they display in their intense love for gardens. The temples and shrines are built in a garden or park, surrounded by numerous auxiliary temples, and houses for the monks; entrance to the temples is made under a *tori-i*, or through a grand gateway as at Shiba, along spacious avenues lined with stone lamps and noble trees on either side, then up long flights of granite steps to a large court or quadrangle, where are numbers of granite lanterns all of one size, given by the Daimios, whose names are graven on them, to the memory of the Shôguns; the courtyards are separated by a picturesque stone or wooden fence, with a gateway in the centre. This fence is framed with posts and rails, dividing it into three horizontal rows of panels; the lower range of panels is filled in with lattice-work, forming a rich diaper design; the middle row has a shaped centre filled with bold conventional carving, and the upper with similar carving, only filling the entire space. The carving is partly pierced, well coloured, and protected by a tiled roof supported upon a cornice of richly carved brackets. The gateway is rather higher than the fence, being covered with an elegant roof of a double curve, supported by circular columns delicately reeded, the top and bottom being covered with bronze plates engraved and gilt, as are also the timbers to roof and entrance gates, while the side panels to gateway, roof, etc., are filled with elaborate carving, full of colour. In the inner courtyard are a number of bronze lanterns of rich design. The temple is nearly square in form, with a small projection at back, containing the sacred shrine. The whole is carved and coloured both on the exterior and interior: the latter enriched with engraved and gilt bronze to parts of columns, roof timbers, and doors, the colours most noticeable being red and black, and the carving generally in light colours, the whole being very rich as a decorative effect.

It is easy to imagine the picturesque effect produced by a number of temples and buildings, seen through the trees in different positions, roof towering above roof, with the background of noble foliage, the temples individually rich in lacquer, carving, gilding, and coloured tiles, intermixed with ends of timbers and posts plated with chased and gilt bronze. Surrounded by a garden, they become the meeting place and holiday grounds of the people. There may be seen majestic firs and cedars, flower-laden plum and cherry trees, avenues of cryptomeria, and miniature lakes filled with iris and water-lilies, and tenanted by golden carp. And thus while sublimity and grandeur of architectural design are absent, the mind

is deeply impressed with the beauty of the surroundings, the marvels of colour, and the exquisite taste displayed in landscape gardening, which have a combined charm distinctively national.

The exterior of a Japanese *yashiki* was very similar to the temples, only designed with greater simplicity—the same pent roof and the same plan. No one imprinted his originality upon the façade of his residence, all were externally more or less alike, only differing in their extent, according to the rank of the owner; they were always surrounded by numerous smaller buildings intended for guards, stables, etc., which gave them a certain magnificence.

The lesser buildings for the farmers, artisans, and traders follow the temples and *yashikis* in plan, and may be described as an outer framing of solid posts and rafters, in lieu of walls, supporting a heavy overhanging roof of tiles or thatch; the roofs are elaborate and heavy, to weight the framing, and as it were to balance the building, and better to resist the shocks of the earthquakes. The exterior skeleton framing is filled in with easily moved sash frames or sliding panels. Draw the panels, shut the sashes glazed with paper, and you have only a poor effect, giving the idea neither of beauty nor solidity. The interiors are divided into rooms, by folding screens, or light sliding partitions often filled with paper decorated with painting, as a substitute for glass, which was not known.

SCULPTURE.

IN sculpture, the Japanese rarely attempted to master the difficulties of drawing the human form. They have undoubtedly been largely influenced by their several religious creeds and systems of philosophy, and it is questionable whether their peculiar rendering of the figure be the result of accident or the want of power; it could scarcely be the latter, for it would appear probable that the artist who could draw the foreshortening of a bamboo spray, and the feathers and claw of a bird in various attitudes, could have accurately delineated a human foot or hand.

The Buddhist and Confucian philosophy produced an effect upon sculpture and painting similar to that of the early mediæval religion upon European art,—a contempt for the beauties of the human form, which came to be treated in a hard, conventional manner. Buddhism gave them the grand and impressive *Dia-butz* of Kamakura, which, although an outrage on anatomy, possesses a certain beauty in the sublime religious reverie expressed in the countenance. Some marvellously perfect wood carving, executed by a Corean sculptor in the seventh century, still exists in Japan, and many fine works were produced down to the thirteenth century by noted temple wood-carvers.

It is, however, in the smaller carvings that the wonderful talents of the Japanese are displayed, and their *netsukes* are often marvellous in their humour, detail, and even dignity. These *netsukes* comprise groups of figures, flowers, birds, animals, insects, in fact almost every conceivable object, rendered with a fidelity, minuteness, and delicacy almost inconceivable. The *netsuke*, or toggle, forms the extremity of a double silken cord, which, after passing through a bead, encircles the *inro*, or medicine case. It will be easily understood how by this arrangement this little case, or more frequently the tobacco-pouch and pipe case, can be

securely attached to the *obi*, or broad band encircling the waist. The true *netsuke* is a kind of button, carved from a single piece of ivory, hard, fine-grained wood, or other materials, of such a form that it can suffer little injury from the wear and tear of daily use. Many of the carvings do not fall under this definition, being in fact mere ornaments, and are called *okemono*, "things for placing." Of these *okemono*, the greater number, and especially the very large ones, are of recent production and are now manufactured in wholesale fashion, for the European market; more than one piece of ivory is frequently employed in their composition, ingeniously joined together with pins and glue; the maker's name is usually to be found engraved in the Chinese square characters on some part of the *netsuke*. There are some carvers of note in Japan, but as the names of these artists are systematically forged, the deciphering of them is of little value in forming an estimation of the age or merit of a *netsuke*. The subject of the carvings is frequently taken from Chinese and Japanese history, stories of the heroes and warriors of the middle ages, legends and mythology, or humorous renderings of the types of man and beast to be seen daily in the streets or fields.

The Japanese incise, or carve in low relief, subjects on ivory tusks, frequently heightened with colour and sometimes with lacquer; they also produce, with marvellous fidelity, imitations of insects, with inlays of various stones, etc. Their temples show the fertility of their invention as carvers. Carving in stone was not so common as in wood; but in the latter material they seem to have given full scope to their wonderful feeling for decorative art. Immense panels of birds and fishes, flowers and fruits, dragons and mythological beasts, treated naturally and conventionally; delicate cut diapers, occasionally with intertwining leaves; reeded columns; and delicate and bold mouldings cut on edges of beams and posts, are to be found throughout.

Their carving is divided into three kinds: shallow, deep, and pierced. In the earlier work, such as the bronze tombs and gates of the early Shôguns, the relief is very shallow, but sharp and effective. In the later work, nearly all carving upon the outside, such as in screens, gateways, and cloisters, is pierced in parts, being cut in a thick slab of wood, so as to be viewed from either side. A striking feature of sculpture of this kind is the extremely careful imitation of natural leaves and flowers, which are carved with a delicacy and truth which is little short of marvellous. Fruit is gilt, with red dashes of colour showing the ripeness, and the greens in colouring the foliage are varied in their tone. The deep carving occurs mostly in the interior of buildings, where depth of effect is required, but at the same time there is no communication with the outer air, which would be obtained if pierced carving were used. The side panels to the gateway at Shiba are filled with thick slabs of wood, carved in the form of writhing dragons, of wonderful design and execution, cut right through, so that the design may be seen from either side. The immense variety of their conventional treatment of birds and flowers, fish and water, is as great in carving as in painting.

———————————

PAINTING.

PICTORIAL art, judged from a European standard, can scarcely be said to exist in Japan; the drawing of landscape, figures, animals, etc., is essentially conventional. Japanese artists learn rather to write than to draw their sketches. They may indeed be called pictorial calligraphists, and in Japan the calligraphist, pure and simple, is almost as much honoured as his colleague of the brush. They seldom, if ever, drew from nature, but for centuries were content to copy Chinese masters, and down to the present time, with one or two remarkable exceptions, may be said to have remained pupils of the Chinese in execution and style. Their method of conventionalizing nature, and treating everything flatly, destroyed their pictorial art, and produced a decorative effect. Ignorant of chiaroscuro, the play of shadows, and the relief which by their use one can give to objects, scenes, and landscapes, they paint all in flat tones as one paints a vase; it is not a picture which they execute on the sized silk, it is a decoration, and it is as a decorative process that painting in Japan must be considered. They have imposed upon themselves from the earliest times a style which they have copied from the Chinese. The more Chinese, the nearer it approached their idea of perfection. The old *kakemonos* are direct copies from the Chinese, and go back to the introduction of art into Japan, and down to the present time the Japanese have chiefly occupied themselves in imitating and reproducing them with almost mathematical precision. The merit of their art, if we may call it such, lies in their method, which, by repeated copying, gives them such accuracy, such perfect touch, and such mastery over the brush. They are feeble in conception, inimitable in execution; masters in the matter of taste, when the human figure is out of the question. In their rough and rapid sketches of birds, flowers, and fish they are perfect, especially in the delicacy of execution and masterly blending of colours.

According to Mr. W. Anderson, late of H.B.M.'s Legation, Japan,* pictorial art in Japan begins as early as the fifth century of our era, by the arrival of a Chinese painter of imperial descent; but whatever pictorial art existed up to the ninth century could not be considered really Japanese, as the few native painters whose names are given in their writings were at best but skilful amateurs. The first true Japanese artist was Kose-no-Kanaoka, a court noble of ancient lineage, who founded the Kanaoka School (*riu*). At this time three schools of painting had been made known by foreign intercourse: *Kara-ye*, or Chinese; *Korai-ye*, or Corean; and the *Butsu-ye*, or Buddhist pictures, wholly distinct in style from the first two, and probably of Indian birth. Motomitsu is spoken of as the originator of the *Yamato-ye*, or Japanese School. In the thirteenth century we find Takuma Tameyuki, a court painter, who is referred to as the chief of the *Takuma riu*, a school which does not differ in any important respect from that of Motomitsu. At the beginning of this century commenced the great *Tosa riu*, which was the outcome of the *Yamato* and *Takuma* schools, and which exists at the present time. In the beginning of the fifteenth century we hear of Zhiyosetsu, a Chinese priest, who came to Japan and established a kind of monastic school at the Temple of Soukokuzhi in Kiôto. Three of his pupils, Sesshiu, Shiubun, and Kano Masanobu became famous; the latter is still venerated as the father of modern art in Japan.

Tosa Mitsunobu, the founder of the *Tosa riu*, was a superintendent of paintings. The followers of this school are highly celebrated as colourists and paint with a fine-pointed brush.

* 'Transactions of the A. S. Soc. of Japan,' vol. vii. p. 4.

Their work is further distinguished by firmness of touch and delicacy of outline ; the designs in gold on lacquer are of this school. Kano Masanobu's reputation, considerable during his life, was afterwards eclipsed by his eldest son, Motonobu, the real founder of the great *Kano riu*, which with the *Tosa riu*, formed the two great art schools, and for more than three centuries afterwards almost monopolized the recognized art teaching of Japan. Sesshiu was so famous for his drawings in black and white that he became known to the Ming Emperor, who persuaded him to undertake the decoration of the Imperial Palace ; the School which bears his name were pre-eminent as workers in black and white.

At the end of the seventeenth century lived Hishigawa Moronobu, a native of Kiôto, who cast off the shackles of tradition and ventured to represent the people and customs of his day, in place of working the almost exhausted field of Chinese antiquities ; his paintings resemble the *Tosa riu* in style, and are very careful in drawing and colouring. He had several followers, but none of great note, hence the *Hishigawa riu*, as it was called, has fallen into obscurity, although its founder is still celebrated as the author of the *Ukiyo-ye*, or popular style. About this time a more healthful style was attempted by Maruyama Ôkiyo, the first artist who had the boldness to demonstrate that something better might be learned from nature than from the orthodox teachers. The result of his labours was the foundation of the *Shijô riu*, the professed principle of which was to paint direct from natural objects ; had it been fully acted upon, the position of Japan in the art world would now have been very different, but Ôkiyo had not strength to break the bonds imposed by the example of the great painters of his country, and the new element was seriously weakened by admixture with the old. Some of the most beautiful works in the country have, however, emanated from Ôkiyo and his pupils.

The beginning of the nineteenth century brought into the field a new set of artists whose designs, reproduced on lacquer, pottery, and porcelain, and in bronze, wood, and ivory, were destined to carry the fame of the decorative art of the Japanese over the whole civilized world. These men, simple artisans, with Hokusai at their head formed the modern *Ukiyo-ye* or "popular school," and signalized themselves as movers in the first assertion of the intellectual independence of their class.

Of Hokusai himself, but little is known ; the only printed records of his life are found in the prefaces, written by his friends, to his numerous works. It is said he was born in Honjo, a quarter of Yedo, in 1760, and was the son of Nakajima Ise, a mirror-maker. As a child he gave promise of his genius, and at an early age became the pupil of Shun-Sui Katsukawa, an artist of some note in his time. Following the puzzling practice of his fellows, he adopted successively several artist-names, but is generally known as Hokusai of Katsushika. Katsushika is a ward of Yedo, in which he appears to have passed the best part of his life. His first forty-five or fifty years were spent in comparative obscurity, and his public career did not commence until about 1810, when he was induced to take a wider range of action by establishing himself in Yedo as an industrial artist and teacher of drawing. Pupils quickly flocked to him, and his original sketches being insufficient to provide them with models, he was led to multiply them by engravings, and to this end the publication of the "Mangua," or "rough sketches," was commenced. The novelty and beauty of the woodcuts attracted immediate attention, and the draughtsman and teacher became almost at once a celebrity in a wide though humble sphere. His fame grew as volume after volume of his book appeared, and edition after edition sold, and there were not wanting learned and clever men to write admiring prefaces to each issue, imitators to print rival works, and a multitude of pupils of his own class to perpetuate his name and style.

The *artisan-artists* had until this time been content to admire respectfully the works of their titled and "two-sworded" superiors, who, almost monopolizing the educational culture as well as the military and civil domination of the country, had hitherto found little difficulty in limiting the practice of art to their own body. It is true that a kind of popular art had been originated by Iaasa Matahei, Hishigawa Moronobu, and to some extent by Hanabusa Icho; but all three of these painters were noted pupils of orthodox academies, and kept the new fashion within the *samurai* circle, while Hokusai, the soul of the *Ukiyo-ye*, was a man of the people, and made no attempt to emerge from the station in which he was born. Perfectly contented with the appreciation of those with whom and for whom he laboured, the chief aim of his ambition was the foundation of the great and essentially popular school, to which we owe directly or indirectly the *artisan-artist* now existing in Japan.

The main characteristics of the older Japanese art may be briefly summarized as follows :— *Composition*, nearly always good, though unguided by written laws. *Drawing*, almost invariably conventional, the outlines of human figures and of most mammalia incorrect, although the action is commonly truthful and spirited, and the proportions true. *Manipulation*, generally good, constituting, in fact, the most important element in the eyes of the native connoisseur, by whom painting was looked upon as a kind of calligraphy. *Colouring*, invariably good, the Japanese being masters in the skilful distribution of harmonies and contrasts ; the tints are seldom gaudy, whilst gold is lavishly used. Many of the greatest artists prefer to use black ink without intermixture of colour, drawings in silhouette, chiefly representing the bamboo or orchid, frequently with marvellous skill, being constantly met with. *Chiaroscuro* is entirely omitted, and projected shadows are seldom depicted.

The present period is one of transition ; the older school of painting is disappearing, and the more inferior of the modern draughtsmen for the most part make a wretched compromise between the native styles, and what they consider to be the Western method, although, according to Mr. Anderson, the ancient skill is by no means lost, and there are yet workers who can equal in execution and originality of design almost anything that has been produced in former times.

LACQUER.

OF all the art manufactures of the Japanese, their lacquer must certainly stand in the foremost rank ; fine as their ceramic and pottery undoubtedly is, it will not bear comparison with their productions in this art. Other nations have produced porcelain and pottery, as fine as theirs, but no nation has originated lacquer ware (*urushi mono*) to be compared with that of Japan. It stands alone for perfection of manufacture, high finish and artistic worth, and its entire originality. Although in most things artistic, Japan is but a reflection of China, in this branch of art there is no comparison between the productions of the two countries. What is known as Chinese, Persian, and Indian lacquer is mere painted wood, compared to the highly finished and beautifully decorated ware produced by the Japanese. When one considers the variety of its applications ; to wood, metal, ivory, porcelain, tortoiseshell, mother-o'pearl, and even egg-shell ; its adaptation to every form ; and its colour, varying from pure gold to intense black, its popularity is not surprising. It is difficult to imagine anything more delicate and refined than some of the masterpieces of this art.

Those Japanese, who have given attention to the subject, fix the date of the discovery of the art of lacquering in the seventh century. It would appear to have attained to some perfection in the year 1290, for the name of a distinguished painter in lacquer, who lived at that time, is still handed down as the founder of a particular school of art in lacquer painting. In the seventeenth century we find the name of Honnami Kuwauyetsu, mentioned as the most celebrated of Japanese lacquer painters. His pupil Kuwaurin, chiefly distinguished in the same branch of art, founded a school of pictorial design known as *Kuwaurin riu.*

In briefly enumerating a few of the various kinds of lacquer, the singularly chaste pure gold (*makiye*) must first be mentioned; then the gold powdered on a black ground, the powdering being independent of, and not interfering with, the landscape or ornament; next in importance may be named the crimson lacquer (*sui chi*), in various shades, and the *nashi ji*, commonly called "aventurine," from its likeness to Venetian glass of that name, consisting of various coloured golds powdered on black-brown ground, often so thickly as to hide the ground.

Pure woods, and various colours are used as grounds, for plain and enriched designs to be worked in numerous shades of gold, silver, metals, mother-o'pearl, ivory and many coloured stones. The designs are flat, raised, encrusted, and even etched, and in fact treated in every imaginable manner, colour, and material. Every kind of ornament, natural and conventional, flowers, plants, birds, beasts, fish, and landscape, have been used, and the best artists have devoted their talents to preparing designs for beautifying and perfecting the art. Some specimens of lacquer are so small, that in colour and refinement they are like jewels, others so large and rich in design and composition, that they resemble pictures, while the form, and mechanical finish, in the largest as in the smallest specimens, is so perfect as a piece of handicraft that it gives additional pleasure to the object as a work of art. The manufacture of lacquer ware is a prominent industry in the country, and one giving employment to many hands.

The groundwork of lacquer consists of the sap of the *Urushi* tree, the fruit of which produces the vegetable wax. The Japanese distinguish between the male and female tree, the former bearing no fruit. In those parts of the country where the trade in lacquer (the crude varnish and not the manufactured ware) is of any importance, the varnish is taken from the tree when it has arrived at an age of from four to eight years; on attaining the latter age the tree is cut down. In Aidzu and Touezawa, where the tree is cultivated for the sake of the wax, the sap is not extracted, and it will be seen to attain the not inconsiderable height of from thirty to forty feet. The *Urushi*, or lacquer varnish tree (*Rhus vernix*), is cultivated either by sowing or cuttings.

The following is a brief description of the mode in which designs are worked in lacquer:—The required pattern or design is traced out on the thinnest of paper, and is then gone over with a composition of lacquer varnish or vermilion, and afterwards laid on to the surface prepared for it, such as the facing of a cabinet or other piece of work, and well rubbed over with a bamboo spatula. On the removal of the paper, the surface below is found to have received the outline, and is now gone over with a particular kind of soft lacquer varnish. When the industry is pursued in hot weather the varnish speedily dries, and consequently where the pattern is involved, such as one representing bunches of flowers or flocks of birds, only a small portion is executed at one time, and the gold powder, which enters largely into most of the lacquer ware for the foreign market, is applied to each part as it is being executed. For this purpose a large and very soft brush is used, and by its

aid the gold powder is well rubbed in with the lacquer or varnish. The work is then left to dry for the space of about twenty-four hours, after which the pattern is lightly rubbed over with charcoal made from a particular wood, which produces evenness of surface; the work is then rubbed with polishing powder and afterwards carefully wiped. This description applies to the mere outlining of figures, birds, flowers, etc., on any given surface or groundwork. There still remains a good deal of finishing work, such as the tracing of leaves on trees, the petals of flowers, the wings of birds, etc., according to the particular subject in hand; into all of this, gold powder largely enters, and the "working in" requires a light brush and skilful hand, to ensure an even mixture of the powder and varnish. After this has well dried, a kind of lacquer varnish, known as *Toshinô urushi*, is used, and the whole then polished with horn dust; the polishing process is done with the finger and is continued until the gold shows out well.

Until about seventeen years ago, the most honourable business among the mechanics of Yedo was that of gold-lacquerer. When the daughter of a *Daimio* was married, it was customary to present her with a *kango* or palanquin, a quantity of toilet articles and boxes, all having the family monogram, or device in gold, on black or other lacquer. The artists in gold lacquer were not permitted to work at their own houses, but were obliged to go to the *yashikis* and work there; it being understood that their charge, however exorbitant, should not be disputed. They were great people in their own way, and always wore silk clothes on such occasions, because cotton was supposed to damage such fine work. At their own houses there were generally employed several apprentices, and it was a profession held in such esteem, and the profits derived from it were so ample, that even the learners would refuse to be adopted into the families of flourishing merchants; but since the changes in the Government and Constitution, there is no longer any demand for these valuable articles, and the business has sunk into total decay. Of old, the skilful artist could lacquer with gold as many as three hundred badges in a single day; and as this lacquer was always in demand, he was never idle. There are still a few gold-lacquerers in the empire, but they have very little patronage owing to the impoverished condition of the disinherited nobles. Mere common lacquerers are plentiful, but are a different class entirely from the workers in gold. The lacquer ware, which at the present time is chiefly manufactured at Yedo, shows much patient execution, and good taste in ornamentation. But while the knowledge of this art can scarcely be said to be lost, it is vain to look in the workshops of to-day for those fine specimens of skill and workmanship which characterized the highly-wrought examples of former times. The artist of a bygone period worked less for gold than the smiles of his patron *Daimio*, and the satisfaction of his own artistic conscience. The measure of remuneration is no longer the same; the workman toils quickly, impelled by the wants of the hour and the haste to grow rich, and copies the designs which a starved imagination forbids his inventing, and thus is witnessed the same sad decadence as in other artistic workmanship in Japan.

CERAMICS.

FOR the following brief outline of the history and characteristics of Japanese pottery and porcelain I am indebted to my friend Mr. W. Anderson, and to Mr. A. W. Franks's Notes in his 'Catalogue of a Collection of Oriental Porcelain and Pottery lent for Exhibition.'

The art of pottery is one in which the Japanese greatly excel, and which they appear to have practised from a very early period : some specimens found on the sites of ancient burial-grounds are said to belong to pre-historic times. None, however, but very rudimentary hand-made unglazed products of the art appear until the eighth century, when a famous priest of Corean parentage, named Giyogi, is said to have invented the potter's wheel, and the first glazed ware appears to have been made a little later. In the thirteenth century Kato Shirozayemon, commonly known as Toshiro, a native of Seto, in Owari, visited China for the purpose of studying the art, and upon his return settled at Seto, where he produced a kind of stoneware which was much esteemed. Various other potteries were established in Owari and other provinces, the wares produced being coarse in substance, simply glazed, of various colours, and sometimes inlaid with a white clay in the Corean style. Little attempt at decoration appears to have been made until the sixteenth century, owing perhaps to the great admiration of the Japanese for Corean ware, which was always plain in character. In the sixteenth and seventeenth centuries the popularization of the *Cha-no-yu*, or tea clubs, gave a great impetus to the potter's art, and many of the quaint specimens to be met with owe their production to this institution. The leaders of ceremonials favoured vessels of a rough archaic character, not turned in the lathe. *Raku* ware, as it is called, which was made at Kiôto, and takes its name from "*Raku*," the mark it bears, and which signifies "happiness," appears to have been especially popular with the tea clubs, but all kinds of ceramic ware were used.

The potteries at Kiôto and those in the province of Satsuma chiefly produced the more ornamental ware. Pottery making was first introduced into the province of Satsuma from Corea in the fifteenth century, when only stoneware, glazed with coloured oxides, and a white ware were at first made ; the finely crackled creamy white ware dates from about 1630 ; and decoration in gold and colours commenced about the middle of the seventeenth century. The decorated pottery of Kiôto may be considered to commence with a noted artist named Ninsei, early in the seventeenth century, when the use of gold and enamels outside the glaze may be said to begin. Modern Satsuma is largely decorated at Tokio and elsewhere. The highly decorated work, so admired in Europe, was produced almost entirely in the present century. Soma ware, produced in the province of Oshiu, consists chiefly of small drinking cups with a rough indented exterior surface, and with a horse painted or in relief, a design said to have been invented by a painter named Kano Naonobu about 1670. Potteries have long existed in other provinces of Japan, and ware of varying character has been produced, but it is unnecessary to give a list of these here.

The introduction of porcelain into Japan was generally supposed to be of some antiquity, but this supposition appears to have arisen from some confounding of pottery with porcelain, and it has now been ascertained that the manufacture of true porcelain, and its decoration (in blue under the glaze), was introduced at the commencement of the sixteenth century by a Japanese potter, named Gorodayu Shondyui, of Isé, who, like Toshiro, had passed an

apprenticeship in the Middle Kingdom. On his return he settled in Hizen, but it is not known exactly where. Arita, in that province, is one of the principal centres of porcelain making in Japan, and furnished during the seventeenth and eighteenth centuries the greater part of the vases known as "Old Japan ware," which seems to have been made for exportation to China and Holland, and but few specimens remained in the country. Kutani ware is made in the province of Kaga, and takes its name from the village Kutani-mura, whence the clay is obtained. The manufactory was founded in the sixteenth century by Tamura Gonzayemon, who had studied porcelain making in Hizen. The older ware is decorated with deep purple, green, and yellow, but about the middle of the seventeenth century a decoration in red was introduced. The present style of ornamentation arose in this century. White porcelain was frequently sent from other parts of Japan to the potteries of Kaga to be decorated.

The manufacture of "egg-shell" porcelain, as it is termed, is stated to have been first introduced into one of the factories of Hizen about 1837. The elegant little saki cups, of pearly texture, delicately decorated in gold and colours, and occasionally enveloped in bamboo basket-work of extraordinary fineness, are produced chiefly in the province of Mino and are painted in Tokio.

It is worthy of note that in the matter of pottery and porcelain the taste of the Japanese differs widely from that of Western nations. While in their lacquer the highest finish and perfection of manufacture is desired, a rough artistic specimen of ceramic ware is far more highly valued by them than the marvels of finish so much admired in Europe. Most of the large and highly ornamented specimens are in fact made for exportation.

The following description of potters at work at the Exhibition held at Kiôto in 1873, from the 'Japan Mail,' may be of some interest :—" Three or four women and a couple of men were engaged in moulding, glazing, and ornamenting saucers and basins of a coarse grey earthenware. There was a single potter's wheel, but the women were fashioning saucers without its aid, and in a way which was novel to me. Taking up a piece of clay, the workwoman flattened it with her fingers into a rude disc ; then bending her left arm, which was covered with calico, till her hand rested on her shoulder, she held the flattened piece of clay in her right hand, and striking it several times against her left elbow, while at the same time giving the clay a half-turn, she quickly succeeded in making a rude vessel, half basin, half cup. I suppose that only moderately young women could thus dispense with the wheel, and only a rounded elbow would answer. One of the men brushed on the glaze, and another, armed with a hair pencil, dashed on a spray or two in a rough style. The sides of the building were open, so that every process was to be seen from the outside, and appeared to afford much interest to the native onlookers. There were a couple of small portable kilns, in which the vessels were to be seen baking."

Pottery is known in Japan under the general term *setomono* or *yakimono*, and the crackled wares as *hibi-yaki ;* the celadon is called *seiji*, and stoneware is termed *ishi-yaki*, a name sometimes applied also to porcelain.

TEXTILE FABRICS.

TEXTILE fabrics constitute a class of art productions for which the Japanese are well known and which they appear to have manufactured as early as the fifth century, when silk brocades are said to have been made by Chinese weavers. The designs are very varied, and executed in every possible manner and material; at one time in pure gold, at another, in the most delicate colours just heightened with gold, while sometimes all the richest colours are thrown together, producing bold but harmonious effects. However powerful they are in their colouring, it is a power which comes of absolute knowledge based on the instinctive feeling for colour, peculiar to oriental nations.

The general dresses of the ladies and the robes of the nobles, in years past, were fine specimens of art manufacture, not only in respect to the innumerable designs embracing every kind of ornament, natural and conventional, affording perfect studies of decorative art, but also in the variety and richness of the material; from the richest satins, plain, decorated and brocaded, the softest silks and crapes, to the most gossamer-like gauzes. Each *Daimio* had his private loom for weaving the brocade bearing his own crest, which he, with the ladies of his house and all his retainers wore on their dresses; these crests were woven in white, or light colours on light silks, and in gold, or dark colours, on black or dark materials. The crests decreased in size in proportion to the rank of the wearer; servants wearing them covering the back of their blouses or tunics and generally printed on the material, while the retainers of highest rank wore them scarcely larger than a florin. Ladies frequently wore a coloured embroidered crêpe, over a rose-coloured silk, which gave it a peculiarly delicate effect of bloom. The crêpes were made in various thicknesses, plain, and wrought into a granulated surface, or in folds and wrinkles, as if in imitation of the skin of an animal; sometimes they were dyed in various shaded colours, the effect being produced by tying up a series of small portions of the surface of white crêpe with cord, forming a pattern; when dyed the colour desired, the cords were cut, and the pattern not only left white, but actually standing in relief on the crêpe, a method which is still retained. Another process is to print a design in white on the material, and to heighten it by embroidering certain parts; for instance, on a robe covered with a design of fir and bamboo, the fir would be embroidered here and there in shades of green, while the bamboo stem would be left white, and the leaves occasionally accentuated by embroidery; in another design, of Wisteria, the flowers are embroidered in parts, and occasionally the leaves, while some birds are wholly embroidered. Their printed cottons are also very effective and covered with charming patterns. In the colours of their grounds, and in the contrasts and harmonies of their designs, the taste of the Japanese is absolutely perfect, combining the most delicate gradations of tints, with equally delicate harmonies or richest contrasts.

METAL WORK.

THE Japanese name for bronze is *kara-kané* (Chinese metal), and perhaps indicates that the art of melting this alloy was originally taken from the Chinese. Japanese bronzes contain copper and tin as their chief ingredients, together with a little lead or zinc. Although Chinese bronze must have been known in Japan for a very long time, still the art of casting bronze guns and muskets was undoubtedly learned by the Japanese from the first Europeans with whom they came in contact.

In the latter part of the fifteenth century the art of ornamental working in metal was greatly advanced by Yuijo, founder of the celebrated Goto family, and a personal friend of the great painter Motonobu. It is said that he and his descendants copied their designs upon sword guards from the drawings of the *Kano* school.

In their modelling for bronze castings the Japanese show wonderful mastery, representing figure scenes, landscape, foliage, flowers, birds, fish, animals, insects, kylins, dragons, and other mythological monsters. These subjects are often depicted in panels, on flower and other vases of very graceful outline. The flowers, leaves, and foliage are wrought out with great delicacy and grace, and the reptiles, fish, and insects are specially noteworthy for their admirable truth to nature; while their dragons and monsters are full of boldness and power. Many of their old pieces of bronze were devoted to the temples, and consisted of altar-pieces, flower vases, and the figures of the numerous gods. The altar-pieces usually consisted of an incense-burner with perforated cover, as a centre piece; a pair of flower vases, placed on each side of the incense-burner, and a pair of candlesticks on either side of the vases. The old vases, both bronze and porcelain, were designed as single pieces, and not in pairs "to match"; the making of vases and other articles in pairs is a practice introduced to meet European ideas.

The Japanese formerly devoted an immense amount of thought to their innumerable designs for sword guards (*tsuba*) and mounts, which were cast or chiselled in iron, and enriched by the addition of various coloured bronzes, gold, silver, and enamels. These sword guards, as well as the small knives, *ko-katana*, attached to the side of the *waki-zashi*, or smaller sword, illustrate the use made by the Japanese of alloys of various colours. The ground is generally iron, which is sometimes simply wrought into a raised design of flowers and other objects, or, pierced to form an open filigree work, without the addition of other metals, but more often the iron guard is inlaid with metals of different colours. Two alloys largely used by the Japanese in work of this nature are *shakudo*, an alloy of copper with about 3 per cent. of gold, by the use of which a blue-black surface, unalterable even by a London atmosphere, is obtained, and *shibu-ichi*, an alloy of three parts of silver with one of copper, of a silver-grey colour.

There are also the small metal plaques, *kanamono*, used for decorating tobacco pouches, sword handles, and for their arms and armour generally. One of these plaques, not an inch in diameter, in the possession of the author, is filled by a half-length figure of a warrior, beautifully drawn and modelled, and contains gold (*kin*), silver (*gin*), *shakudo*, *shibu-ichi*, and copper, on an iron base or background. The *shakudo* is inlaid with the most delicate ornament in gold and silver, while the *shibu-ichi* is inlaid with gold and *shakudo*; the face and hand is finely modelled, and the cap, arms, and armour are in high relief, the whole forming

a perfect work of art. Another branch of metal work peculiar to the Japanese is the inlay of gold and silver in bronze and iron, conventional ornament, plants, flowers, birds, etc., are worked out with the greatest delicacy, in fact it may be said that sketches are thus made in gold and silver line, on a background of bronze or iron; the background often being coloured; as, for instance, silver outline on a copper-coloured ground. Some of the gold inlay has all the delicacy of Eastern damascening, to which it bears a strong resemblance. Repoussé work is not unknown to the Japanese, although less common than many other of their methods of working metals.

At Shiba there are exquisite cast bronze dragons serving as water spouts, elegant bronze lamps full of good modelling, and the pedestals to the bronze figures of Buddha often consist of well-designed forms of the lotus. One of the Shôgun's shrines is wholly of bronze; it is some 10 feet in height, covered with a curved, projecting roof, with chains and bells attached to the corners, the name of the Shôgun sharply cast, and delicate mouldings and foliage executed with great skill. The whole is enclosed by a low railing, gates in solid bronze, diapered on the surface with the favourite key pattern. The tomb is set back, and in a line with the front of the wall. At the top of the steps is a little gateway, with roof and double gates, all of bronze. The heavy gates are diapered with very shallow but sharp ornament; and the side wings or walls, also of bronze, are ornamented with casts of two peacocks in low, sharp relief. All the ornament is much more severe, more sparingly used, and the parts much heavier in proportion than the other tombs. The facility with which bronze and metals generally are wrought into plastic forms is equal to that shown by the Japanese in clay modelling.

ENAMEL.

IT is a question when the art of enamelling first arose, but that it dates from the earliest times is certain. Pottery as an art doubtless preceded the manufacture of glass, and probably originated in Phœnicia or Egypt, but that vitrification had reached a high degree of excellence more than twenty centuries ago, we learn from Greek and Roman specimens. The discovery of enamels follows, as a natural sequence, upon the knowledge of pottery by the ancients, and necessarily the whole class of vitreous subjects, either transparent or opaque, are equally applicable to pottery, porcelain, and metals.

Enamelling is of three kinds,—cloisonné, chamlevé, and surface enamel painting. Cloisonné is made by soldering a thin ribbon of brass on to a copper ground, the brass forming the outline of the design, and dividing the surface into small cells or *cloisons*, which are filled by the enamel in a pasty state in various shades of colours as required, and the article is then placed in an oven or muffle and fired until the paste is fused and converted into a vitreous substance, which is then allowed to cool; when withdrawn from the furnace, if the enamel has been successfully fused, it passes into the hands of the polishers, who carefully grind down all

the irregularities and make the surface perfectly smooth. All this requires great care and judgment, and a piece of work may have to be fired three or four times, and may at last be easily spoilt by too great a heat. Chamlevé is produced by tracing the design on a bed of metal and cutting out the metal or *field* to form a receptacle for the enamel, leaving the divisions in relief. Surface enamelling, generally known as " Canton enamel," consists of thin plates of metal covered with an opaque coating of enamel, upon which designs are painted with a brush charged with enamel pigments, and fixed by firing; this kind of enamel does not appear to have been produced in Japan.

Cloisonné is the most ancient method, and is the enamel generally made in Japan; it is both translucent and opaque. China formerly made the finest enamels, but of late years Japan seems to be equalling if not surpassing the productions of the former country. Europe has never produced anything to be compared with the best Chinese or Japanese cloisonnés. A few years since M. Christophile, of Paris, devoted much time and money with the praiseworthy object of producing cloisonné enamels, but although some very beautiful articles were made, they were not equal to the originals either in design, colour, or cheapness.

DECORATIVE ART.

THAT the Japanese are consummate masters of decorative art there can be no question, and much as they have to learn from Europeans in certain directions, Europe has much to learn from them in others. The fear that a bastard art of a very debased kind may arise in Japan, is not without foundation, and the art world is too much interested in the preservation of pure types to regard with indifference any measure which threatens their extinction. The European artist, who will study the decorative art of Japan carefully and reverently, will not be in any haste to disturb, still less to uproot, the thought and feeling from which it has sprung; it is perhaps the ripest and richest fruit of a tree cultivated for many ages with the utmost solicitude and skill, under conditions of society peculiarly favourable to its growth.

The works of Chinese artists were in the first instance the models which the Japanese took for their guidance. For 1500 years these works were religiously copied by them, and the style is still followed for pictorial effect, as evidenced in the *kakemonos*, or hanging pictures, most prized by native connoisseurs. It is only within the last two centuries that the Japanese have emancipated themselves to some extent from their Chinese models, and produced a school of decorative art peculiarly their own. The influence of their Chinese masters is however still strongly felt; like them, the Japanese artists are all ignorant of *chiaroscuro*, and of the mystery and beauty of shadows. All objects and landscapes are painted flatly, and without relief, and although by certain tender effects of colour, much poetical feeling is occasionally introduced into a scene, as clouds round mountains, or mists and rain-storm over sea or forest, the mode of treatment is in every instance purely decorative.

Keen admirers of nature as the Japanese are, and fully alive to all the wealth of flower, foliage, and scenery in which their country is so exceptionally rich, it must not be supposed that their art is entirely the outcome of their own observation. Doubtless their love for nature produces upon the minds of the native artists certain impressions, which they more or less unconsciously produce in their works, but until within the last five or six years, when they began to follow European teachings—followed thus far with lamentable result—it is safe to affirm that *their productions were rarely the result of deliberate or direct study from nature.* The power of the artist's effects, the wonderful facility of his execution, the beauty of the colouring and delicacy of drawing, all combine to give what may pass for a marvellous transcript of nature, but taken separately and examined critically, the objects depicted, be they bird, flower, leaf, or insect, will be found incorrect in form, proportion, and construction, if judged by a European standard. Yet in these very failings are found their highest merits as decorative artists. Decorative art does not admit of absolute fidelity to nature; slavish copyists of nature, lacking imagination, can never be true decorative artists. The very essence of decorative art is the power of conventionalizing nature, while retaining all the spirit and feeling of the object represented, and this is where the Japanese especially excel. Gifted with wonderful quickness of perception, and delicacy of hand, they can seize upon and reproduce, with extraordinary rapidity and power of touch, the characteristics of natural objects. Their method of writing is alone sufficient to give them great facility of execution, as all the letters—or rather characters—of the language are written with the brush, which they are thus accustomed to use from their earliest childhood. Thus they acquire that rapidity of hand and decision of touch which are such noticeable features in their drawings, and which have compelled the admiration of foreign art connoisseurs. The Japanese artist learns to draw as he has learned to write. He does not sit down opposite a model or natural object and endeavour to represent it as it appears to him; as he learns to form the innumerable and complicated characters of his language by constant repetition, so does he acquire the power of drawing certain designs and conventional forms, by long continued copying of accepted models, which have been handed down from generation to generation. This very method of procedure, while fatal to the excellence which he might attain as a student of nature, gives him that decorative power in design in which, as we have said, the Japanese artist stands pre-eminent.

A small manual of drawing, in which different designs are mapped out in squares, is placed in the hands of the student, who divides his drawing paper into the same number of squares, which he is taught to fill up in their fixed order. When he has learned these by heart, designs of gradually increasing difficulty are placed before him, and thus he learns by degrees to delineate flowers, birds, landscapes, figures, and other objects, in an artificial manner, without any reference to nature. One student may devote himself to birds and flowers, another may take up the subject of landscape, but in all cases the method pursued is the same, and thus the excellencies and faults of the originals are perpetuated. Individual talent in draughtsmanship—looking to originality of design—can scarcely exist. The excellencies of artists are therefore confined to the combination of conventional forms and the delicacy or power of execution and colour, in which alone their fancy can have free play. These elegant stems, those feathery petals, apparently thrown together without restraint, are thus executed after a number of models prepared long beforehand, and which every painter possesses.

Introduced into an artist's studio, well lighted and arranged, we can pass in review the resources with which he prepares his models, and the heaped up sketches in large sheets. The apparatus of a water colourist is very simple; a few cakes of vegetable or mineral colours in a little box, some fish glue diluted, for varnish, a stick of China ink, several pencils such as are used for writing, with grey hair, spreading at the bottom, a few large saucers, one taking the place of a palette, a little earthen pan of water, all spread upon the floor to the right of the worker, who is squatting upon the ground, stretched upon his elbows, and turning the pencil toward the sheet of paper spread out before him. It would be too tedious and complicated to fix it on an easel, and the vertical position would not easily allow large drawings to dry on the paper or the silk. Our artist gets to work leaning in the position just described; the left hand holds the right to steady it; soon the paper begins to be covered with China ink, with three strokes of the pencil is produced a confused black form, which will directly represent a rock, from thence springs a slender stem surmounted by a wheel with open spokes; this wheel is transformed into a chrysanthemum, then the stem is covered with leaves, it throws off other flowers, in each one can count the number of strokes of the pencil, sometimes one serves alone to represent the curling of a twisted leaf; striking this way and that with vigour, and without ever starting a second time to finish the same line, or giving himself an instant of rest or reflection, the artist works with the rapidity and precision of a mechanic.

Absolute master of effect, the Japanese artist seeks to produce it by the smallest possible effort, and it is in this particular that his surpassing skill in handling the brush, that skill which is the outcome of his common education, is shown, and in which he is unequalled by the artists of any other country in the world. A few masterly strokes and he has produced a branch laden with cherry blossoms, a plume of feathery bamboo, a bird darting through the air, or balancing on a slender spray, which, if not botanically or ornithologically correct, have in them life and action and suggestiveness of nature, and which are, in view of the remarkably slight means employed, unmatchable by our best artists, and unsurpassed as decorative works. The same method of decoration and ornament is employed for all purposes and in all materials. Thus the ornament used on lacquer will be found on ceramics, bronzes, stuffs, and enamels; no special ornament is employed for any special material, the drawing books have served alike for all.

Of grand harmonies the Japanese have scarce an idea, but when it is a question of flowers, of birds, of fish, they display all the wondrous cunning of their pencil, all the resources of their palette, to render the representation satisfying to the beholder. A bird perched on a branch of a tree, a few flowers grouped together with exquisite relation of colours, and such like subjects are those which they love to display. The Japanese painter commends himself to us by the delicacy of his execution and the harmonious blending of his colours. He knows the exact science by tradition, he has learnt the law of contrasts and that of complementaries, but of the poetry, the emotion of colour, he is generally ignorant. He applies mechanically the rules he has had handed down to him without ever attempting to emancipate himself from the mechanical process.

Doubtless the peculiar power of colour possessed by the Japanese is to a great extent due to the beauty of their climate, which gives to objects vivid and delicate tones, of which in our less favoured land we are unhappily ignorant. In spring and autumn no other country in the world affords such variety and beauty of colouring, while the peculiar atmosphere in

which the sun shines with a softened splendour, gives to all natural objects enhanced beauty, so that one ceases to wonder that the Japanese artists have been induced to endeavour to reproduce in their works some of the brilliancy which surrounds them. Thus it is that they have ventured to paint as in a golden atmosphere of sunlight, landscape and natural objects on a ground of gold ; to try to represent the golden mists which hang round the hills in the autumn evenings, by powdering of gold and flakes of metal, which only the true decorative instinct could dare, and which nothing but surpassing skill could successfully accomplish without vulgarity.

The specially national and unmixed character of Japanese art is due to the isolated position which, until within the last few years, she has maintained since the earliest ages. With the exception of China and Corea, she has had no intercourse with any nation which could in any way affect her art productions. We have seen that China was her art master, and that on her teachings she has founded her own school. It is not, as in Europe, the grafting of one style upon another, and the accumulated knowledge and practice of all the various schools of art from the remotest antiquity ; it has been a growth unaffected by any extraneous influences, self-contained and strictly national, and hence the astonishment and delight created when the art of Japan was revealed to the outside world by the opening of the country. It is when we consider the *decorative* art of Japan that we find how for many years they have distanced their Chinese masters, and produced a style peculiarly their own. Studying its application to ceramics, lacquer, bronzes, costume, etc., we see the ground upon which they triumph, and we recognize the superiority of their art.

The commencement of the nineteenth century gave to Japan a new school, the educated *artisan-artist* created by the genius of Hokusai, and the right to boast of a truly national art, which, although adapted from the old models, and still tainted with many antiquated errors, abounds in novelty and character. and shows unlimited capabilities of development. The men who formerly led the educated world in matters of literary and artistic taste were all conservative in the ancient canons and aristocratic practice of art, and closed their ears when the plebeian draughtsmen ·were spoken of, for, with the critic, painting was essentially an occupation appertaining to gentle birth and classical culture ; its practice, once almost confined to royalty and nobility, never descended below the *samurai*, and, though not strictly hereditary, was so far transmitted by family descent and adoption that more than one-half of the names known to fame belong to a few ancient lines. But the Hokusai School became an established fact, in spite of the contemptuous neglect of those who should have been its patrons ; and its outcome, the *artisan-artist*, has given to the world at large not only the wealth of strange ideas and manual skill, so long imprisoned by the pride of seclusion, but has added to it no small portion of the sum of originality to which it can lay claim. Labouring diligently over a *netsuke*, colouring a vase, or sketching a design for a woodcut, we find him, gifted with talents of a very high order, telling us in his own manner the history and legends of his country, showing quaint touches of his own mother-wit, or putting into form an original observation of some simple, oft-repeated motive of bird or flower. He is commonly nothing but a copyist, but he is a skilful one, and repeats with the eye of understanding the experiences of form, and colour, that have accumulated during the preceding ages, and have been placed in his hands as models. These models, with their absence of light and shade and of strict accuracy of detail, are far less difficult to imitate than would be the more advanced works of the European schools.

If we study the decorative art of the Japanese, we find the essential elements of beauty in design—Fitness for the purpose which the object is intended to fulfil, good workmanship and constructive soundness, which give a value to the commonest article, and some touch of ornament by a skilful hand, together creating a true work of art.

Japanese art may now be said to have culminated, and to have shown all that it is capable of producing, and it is with pain we perceive that the hour of decadence has arrived, for all modern Japanese work shows the inability of the artist to preserve its original delicacy, or to blend it harmoniously with foreign elements. No student can fail to recognize the signs of impotence and the depreciation of taste. It may not be too late to awaken the Japanese to a sense of the wrong they are doing to their national art, in which they might, if they so chose, continue supreme ; but should their intuitive taste be overlaid by imitations of European vulgarities, it is no unimportant task to preserve the records of the most brilliant period in the artistic life of a singularly gifted people.

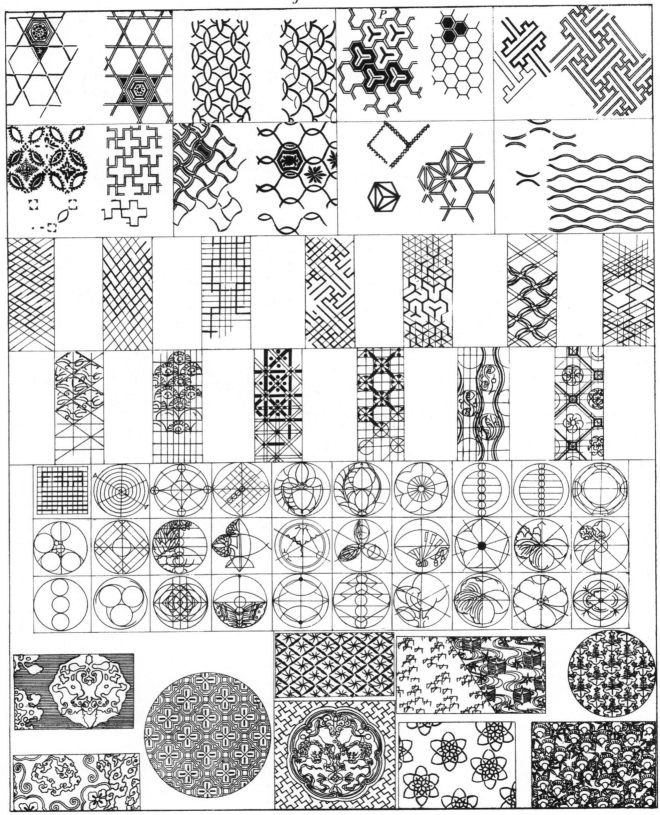

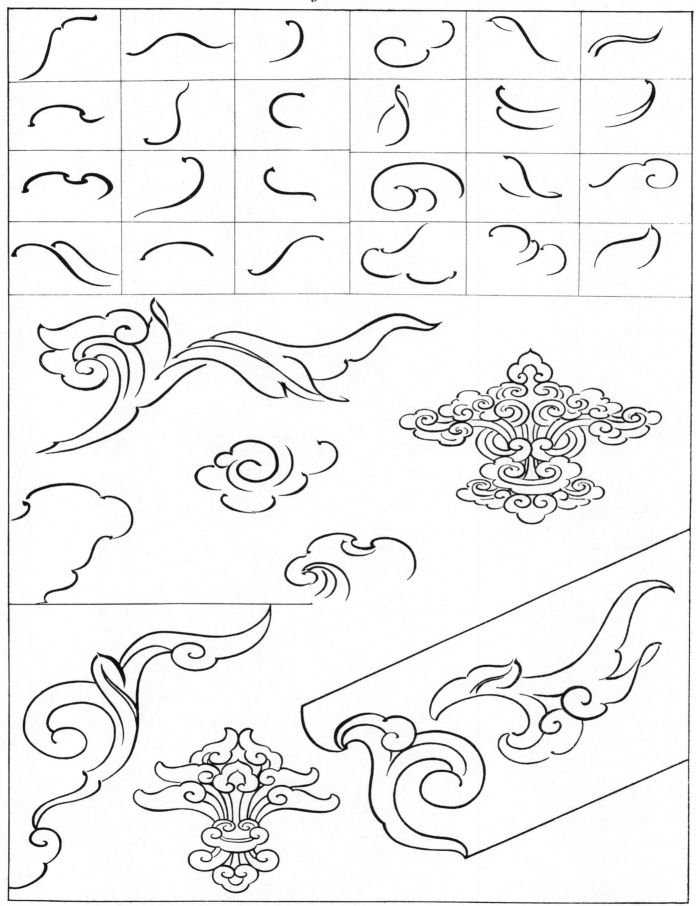

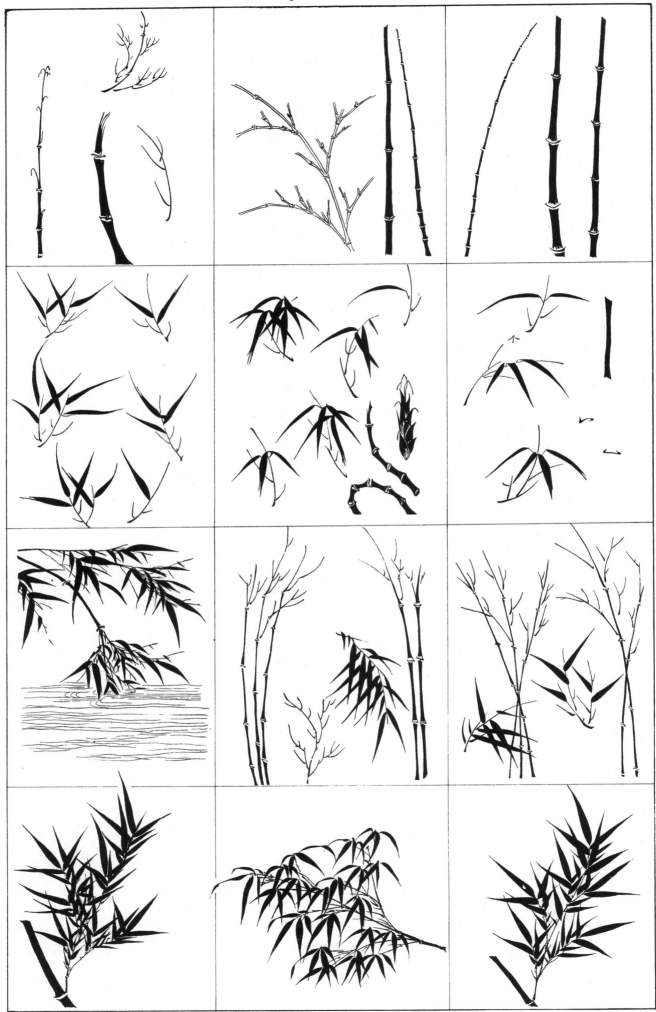

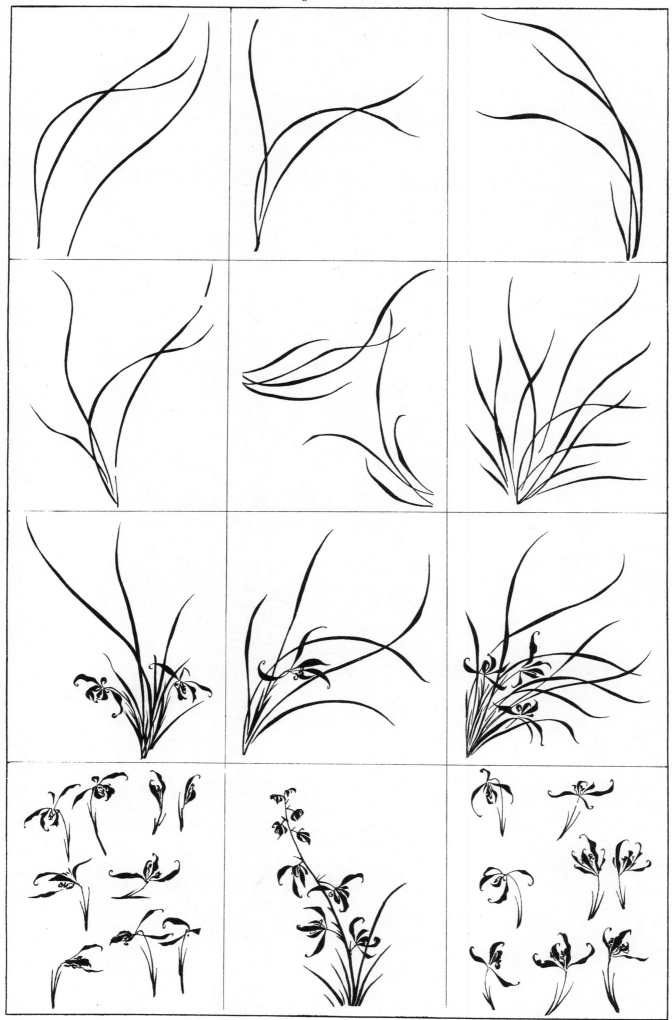

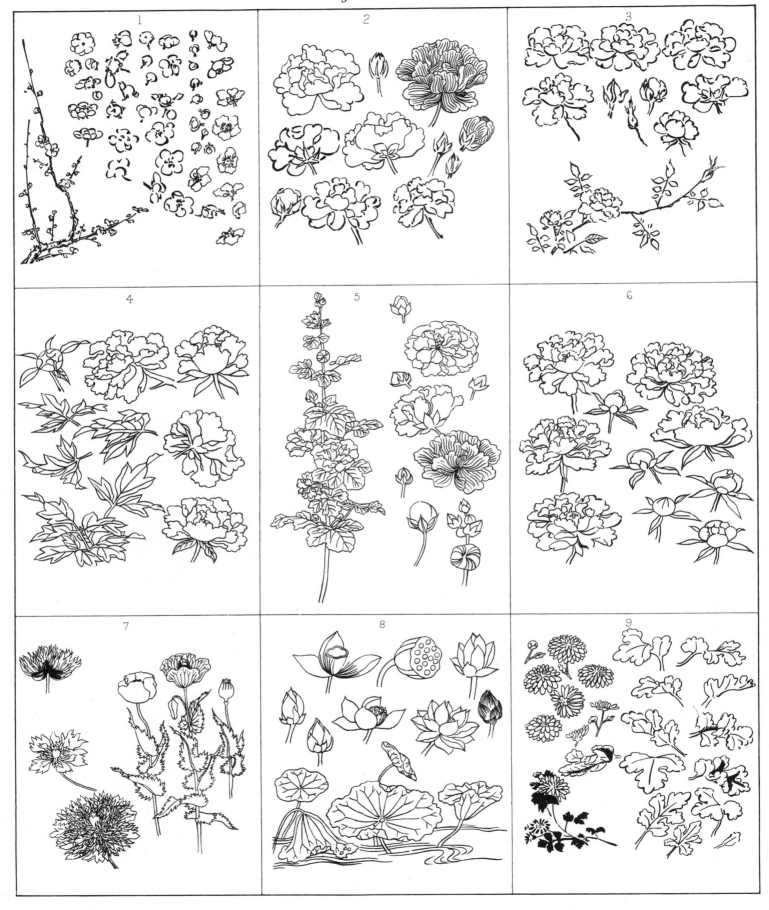

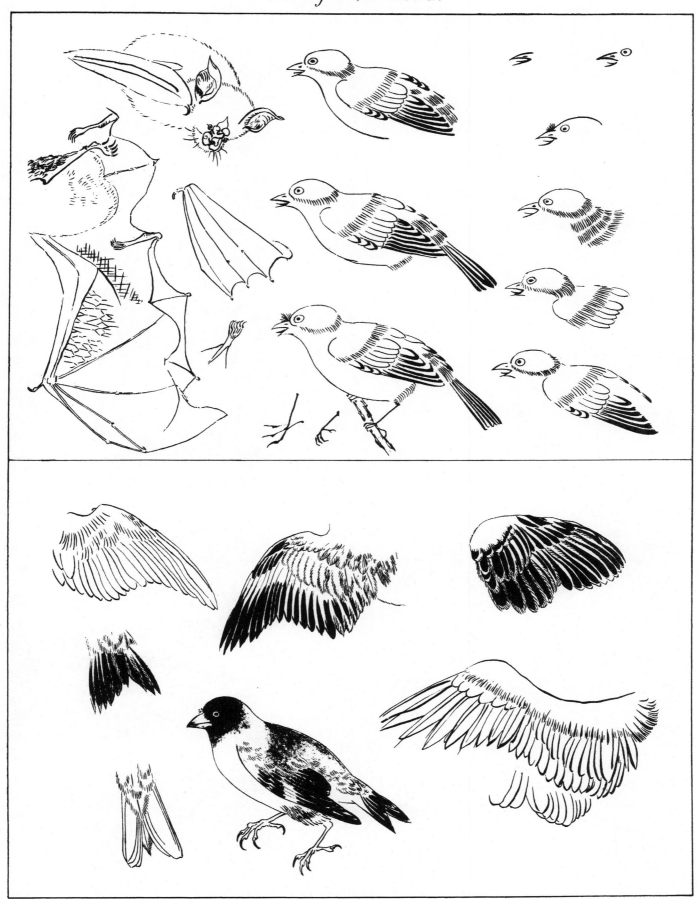

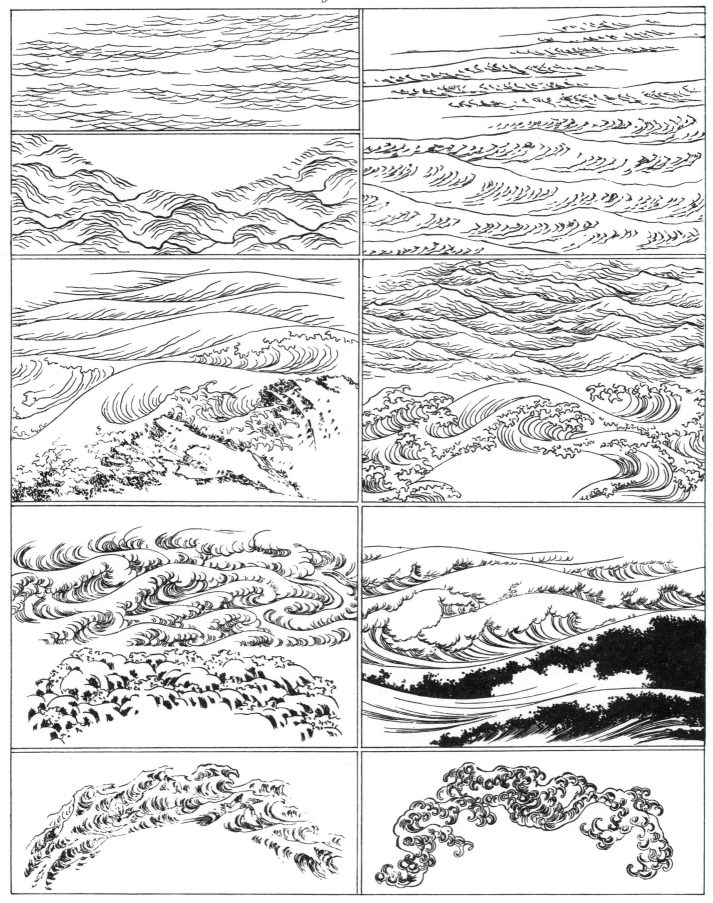

ANALYSIS.

I N attempting an analysis of Japanese Ornament, we find in the elementary or geometrical forms some resemblance to those used by other primitive peoples, but whether this resemblance is the result of accident, or that these forms were copied from the productions of other nations, cannot be decided until we arrive at some further knowledge of the early history of the country. It would perhaps be safe to assume that the Japanese, like other tribes of which we have more positive knowledge, following a common artistic instinct in their early attempts at decorating their various implements and utensils, first used straight lines in various combinations, proceeding then to curves, and thus developing the many and charming geometric designs with which most of us are now familiar. Leaving these geometric forms, of which there is to be found an almost infinite variety, we cease to trace any but the slightest resemblance between the decorative work of Japan and other countries, China alone excepted. That much is common to these two countries is evident; indeed, as has been said in the " Introduction," the Chinese were their teachers, but in their adaptations of natural forms to decoration, the Japanese have evidenced far greater originality of thought and boldness of conception than their early masters, and have produced an art which for its masterful presentment, in a truly decorative spirit, of the charming natural objects with which they are surrounded stands unrivalled in the world's history.

It would be a difficult task to attempt to set forth any general principles which *may* underlie Japanese decorative art, but there are numerous characteristics pervading all classes of their work, of which a few may be thus briefly described. An avoidance of the appearance of symmetry while producing symmetrical effects, a suggestion rather than expression of proportion, an unobtrusive order, and in repetition of form an irregularity and changefulness, giving to it an unusual charm and freshness. A Japanese artist proceeding to decorate a given space would not mark out the centre and place his ornament there, nor would he divide it into equal parts, but he would most probably throw his design a little out of the centre, and cleverly balance the composition by a butterfly, a leaf, or even a spot of colour. This is but a simple example, but it sets forth an essential element in Japanese decoration.

Undoubtedly the most characteristic feature of Japanese ornament is the presentation of certain natural subjects in almost endless variety and with ever-varying degrees of conventionality, now approaching so closely to nature as to be almost pictorial representations, now so thoroughly conventionalized as to be well-nigh geometrical; and here it may be noticed that whereas in the higher developments of European decorative art the human figure and that of the horse have invariably held the foremost place, in Japanese art these forms are rarely found, and although when met with they show a marvellous amount of graphic power, they are treated with far less delicacy and truthfulness of observation than is bestowed upon the birds, fish, insects, flowers, and trees, which the Japanese artist loves so well to portray, and upon which he expends the utmost power of his brush and the long-treasured stores of his artistic training.

The examples of diapers, circles, and medallions shown on plate A are taken from well-known native drawing-books, and are given rather as showing the artists' method of setting out their designs than as specially striking in character. The design marked P, at the top of the plate, is common in Persian work, and did space permit it would be easy to multiply examples bearing a more or less close resemblance to Egyptian, Pompeiian, Hindoo, Greek, and other styles. Several of the circles on this plate show the geometrical bases of badges illustrated on plates 51 and 52. Frets are largely used by the Japanese for borders and diapers, and the so-called " Greek key pattern," which has been common to many countries from the earliest times, is drawn by them in various ways, detached and in combination. They are prolific in designs for diapers, and in covering surfaces frequently use six or eight on one object, distributing them irregularly. Nests of drawers, or boxes, will sometimes be ornamented with diapers over the entire surface, without regard to the divisional lines, or with a different design for each drawer, which if executed in gold will often have a change of colour for each. Diapers overlaid with circular and other forms of varying character are also commonly met with; some examples of this description will be found on plate 46, fan overlying fret; 47, medallions on fret; and 56, blossoms scattered over fret. Plate 47 exemplifies the not uncommon practice of leaving a few plain spaces here and there, as if the design had been blotted out, which breaks the evenness and gives character to the design.

On plate B are shown some studies of curve lines made with single brush strokes, and some of their combinations, producing various designs for carving or ornamenting ends and parts of timber framing to buildings, which are full of graceful outline and distinctive character: the same series of curves is used in forming the conventional clouds so frequently found, an example of which is given on plate 6 (flying cranes) and again on plate 58 (conventional dragons in clouds). Some examples of free-flowing scroll-work are illustrated on plates 49, 57, and 58.

Plate C shows a graduated series of studies of the bamboo, in which are depicted with marvellous fidelity the varying stages of its growth, from the early budding stem to the perfect branch with full and flowing leaves, drooping in the silent air, or gently swayed by the breeze. The bamboo may almost be ranked as the national tree of Japan, and plays an important part in the social economy of the country ; its earliest shoots and mature seeds are eaten as foods, the largest and medium sized stems are used for flagstaffs and scaffolding, split they form the laths of the house-builder, and the articles of domestic utility in the manufacture of which this tree is used are well-nigh innumerable. In decorative art—on lacquer, porcelain, metal-work, carving, drawings, and the woodcut illustrations to books—it is constantly depicted alone and in combination with the pine and plum. The bamboo is held by the Japanese to symbolize fulness of life, and in the combination named it is an emblem of longevity, and is used in decorating the entrances to houses on New Year's Day. Some applications of the bamboo in decoration will be found on plates 37, 39, 42, and 49.

Some idea of the care bestowed upon the study of flowers for decorative purposes may be gathered from the examples given on plate E, which show the leaves and blossoms in various stages of development of the plum (1), the rose (2 and 3), the peony (4 and 6), the holly-hock (5), the poppy (7), the water-lily (8), the chrysanthemum (9). This series is taken from a drawing-book prepared for the use of students. Applications of the cherry in design will be found on plates 25, 31, 39, 41, of the plum on plates 28, 30, 32, 42, 48, 49, and 53, of the rose on plate 42, the peony on plates 28, 40, 41, 49, and 55, the water-lily on plate 29, and the chrysanthemum on plates 24, 40, 50, and 56. The well-known fondness of the Japanese for flowers cannot be better illustrated than by a brief mention of the " Flower Festivals " held at different seasons of the year, and which occupy a prominent place among the recrea-tions of all classes of the population. These festivals are, the plum festival held in February, the cherry festival held at the end of April, the wisteria festival held in June, followed shortly by the iris festival, which is succeeded by the chrysanthemum festival held at the end of October, when this chief favourite of all their cherished flowers attains its full bloom. The chrysanthemum, or "kiku" as it is called in Japan, has been adopted in the Imperial escutcheon as emblematical of the Mikado's house ; the badge may be observed upon weapons, porcelain, lacquer, and even the parti-coloured cakes which it is usual to present to the guests at the Imperial court, bear it. Many other of the flowers of Japan have been adopted as badges by the nobles ; several of them are illustrated on plates 51, 52, and 54.

Great as is the power and skill displayed by the Japanese in depicting the varying forms and growths of the vegetable world around them, their greatest success is reached in the portrayal of the birds, fish, and insects, which are equally common objects in their decorative work. It is perhaps in the drawing of birds in every variety of position that their wonderful power of presenting with a few touches of the brush the most vigorous and life-like transcript is most fully shown. A very superficial examination of Japanese art productions is sufficient to make us acquainted with the graceful form of the crane, which is depicted grouped in every possible attitude, flying with graceful sweep mid conventional cloud, or poised above the favourite pine or bamboo. The crane is held in much veneration by the Japanese, and until recently a prohibition existed against its destruction by any except the *Daimios*, the penalty being death. There are three varieties of cranes in Japan: The *Grus leucauchen*, or white-naped crane, which is the sacred bird of Japan ; the *Grus leucogeranus*, or white crane ; and the *Grus communis*, or common crane, found also in other countries, the first of these being most commonly depicted by the Japanese artists. The crane is frequently confounded with the stork, a bird to which it has no affinity. A number of characteristic examples of cranes,

natural and conventional, are shown on plates 1, 4, 6, 12, 39, and 41. Of the other birds generally used for decorative purposes, the principal are the hawk and falcon (for illustrations of which see plate 5), the peacock, the pheasant (plate 11,) the kingfisher (plate 3), the jay (plate 2), the swallow (plate 8), the wild goose (plate 9), the mandarin duck, and domestic fowls (plate 10). Various birds highly conventionalized for badges are given on plate 45. It is somewhat remarkable, considering how constantly birds of various kinds figure upon Japanese art productions, and the care and skill shown in depicting them, that no complete series of detailed studies, such as that of the bamboo shown on plate C, appears to exist; in some native drawing-books a great variety of rough sketches of birds on the wing and perching in various attitudes are to be found, but they are mere outlines. In the sketch-books of some native artists studies of great merit are to be met with; those shown on the lower part of plate F are from one of these. The upper part of this plate gives some studies copied from a Chinese manual or drawing-book, some two hundred years old, which undoubtedly formed the basis of the modern school of Japanese drawing; they are hard and mechanical, as Chinese work invariably is. A glance at any good specimen of modern Japanese will show how great is the advance which they have made in true artistic power and manipulation.

It is unquestionable that amongst the objects of the animate world fish rank next to birds in popularity with the Japanese artist, and in nothing does he display more marvellous power and skill than in producing a vivid representation of these denizens of the deep. A shoal of fish swimming, a carp plunging down stream, or leaping up through a waterfall, are favourite subjects; lobsters and crabs are also drawn with great skill. It is worthy of note that whereas only living birds are depicted, dead fish are frequently to be met with. A pair of dead carp strung upon a branch of bamboo are shown on plate 16. It may be added that the employment of fish in decorative work is as general as is that of the other natural objects already described. Some very characteristic examples of fish, both natural and conventionalized, will be found on plates 13 to 18. In the drawing of water the Japanese show all their wonted originality and power, and portray with marvellous freedom, almost always in a thoroughly conventional spirit, the gently rippling stream or the restless ocean in its ever-varying moods. The series of studies shown on plate G is copied from one of the native drawing-books; other examples of water will be found on plates 13 and 18.

Plates 19 and 20 give a good idea of the skill with which the Japanese depict the various forms of insect life. The grasshoppers, crickets, beetles, bees, and wasps shown on plate 19 are most frequently met with, and are used in the ornamentation of all classes of ware and fabrics; besides these, moths and butterflies are largely used. Plate 20 is a fac-simile of an old kakemono, and represents a procession of grasshoppers, wasps, and other insects; in the cage is borne a beetle, and various grasses and flowers are carried as insignia; the mantis beetle is ridden like a horse. The whole is a caricature of a *Daimio's* procession.

Although far less frequently than the flowers and plants, birds, fish, and insects already mentioned, various animals are met with in Japanese decorative work, but they are invariably treated with less care, and fidelity to nature. Foremost amongst them is the horse, which is drawn with much character, and is most commonly found on the pottery ware of Soma. Other animals sometimes used in decoration are the fox, the monkey (for the drawing of which some artists have been highly celebrated), and the badger. Oxen, deer, dogs, and cats are occasionally met with on embroidery. Rats, mice, hares, and rabbits are carved to form *netsukes*, and are cast in bronze; the elephant and tiger are sometimes depicted, but so incorrect in

drawing as to be almost grotesque. It is worthy of note that in Japan the twelve signs of the Zodiac are represented by animals. Other members of the animate world which are occasionally introduced into decorative work are serpents, lizards, toads, frogs, and the tortoise. On plate 21 will be found illustrations of the lizard and frog. There are also several mythological objects constantly used, notably, the dragon, of which a good example is given on plate 21, the hairy-tailed tortoise, the phœnix, the kylin, and the lion of Corea, which are met with on all kinds of work.

The unquestionably high and distinctive position which must be assigned to the Japanese as decorative artists, is doubtless due to their skill in treating conventionally the objects of the animal and vegetable world which surround them, and the constantly varying degree of this conventionality, which gives to their productions a variety and charm which would be absent were they the slaves of any rule or method. A slight acquaintance with Japanese decorative work is sufficient to show how widely different is the treatment of the same familiar objects, the representation sometimes approaching closely to a study from nature, at others being so freely conventionalized as to verge upon the grotesque, yet retaining withal its distinctive characteristics; but between these two extremes are to be found delicate shades or degrees of conventionalism which will fully repay a careful examination. The utilitarian would naturally expect to find that the more conventionalized renderings of natural forms were designed to suit the material in which they were to be worked, but this is not the case. The Japanese are not an utilitarian race; the whole of their productions in the past speak of a leisurely and loving devotion to the work in hand, considerations of the time and labour to be expended upon it holding no power over the artistic mind. Thus we find some marvellous reproductions of bird or insect life chiselled in the most unyielding material, iron, ivory, or hard-grained wood, with a fidelity truly surprising. Perhaps the most extreme examples of conventionalism are to be met with in the decoration of flat surfaces, and on the badges of the nobles, which form the native heraldry. That inherent love of Nature's works which is so constantly insisted upon by nearly all writers, as characteristic of the Japanese people, is strikingly illustrated by the predilection which they show for some form of bird, insect, flower, leaf or spray in their choice of these distinguishing insignia.

An examination of a few of the plates in this volume will enable the reader to form some estimate of the power of conventionalization possessed by the Japanese, and of its variation in degree. Plate 1 shows a number of cranes drawn naturally (figs. 1 and 2), and a group conventionalized (fig. 3). Plate 12 gives a fine group conventionalized (from embroidery). Plate 6 gives some good flying cranes, and plate 4 shows a charming arrangement of cranes and water, more highly conventionalized; the treatment of the water is very characteristic, the manner of depicting the waves in the distance with cranes flying over them, and the gradual change as they approach and break upon the shore, is exceedingly skilful. This plate is copied from a carving in bamboo. The kingfishers on plate 3, figs. 1, 2, 3, are natural; figs. 4, 5, and 6 are conventional. The birds shown on plates 2, 5, 7, to 11 are drawn naturally; some highly conventional birds will be found on the badges given on plate 45. The fish shown on plates 14, 15, and 17 are good examples of natural drawing, and are all taken from paintings on silk; those on plates 13 and 18, the first from lacquer and the latter from embroidery, are conventional. Plates 19 and 20 give various insects which may be taken as natural. Plate 54 gives some highly conventionalized butterflies used as badges. Plate 27 shows natural chrysanthemums, and plates 24, 49, 50, and 56, various forms and degrees of conventionalizing the same flower. Plate 28 shows the peony and the wild plum drawn naturally; plate 55 a good conventional rendering of the peony from embroidery. Plates 25 and 26 are

examples of naturally drawn cherry blossom, which will be found slightly conventionalized on plate 31 (from embroidery). Plate 30 shows the plum and bamboo almost naturally depicted; plate 39, cherry, bamboo, and fir; plate 42, plum, bamboo, pine, and rose; plate 32, plum and bamboo conventionalized; plate 48, plum and fir overladen with snow. Most of the plates of flowers and plants not referred to here may be said to be naturally depicted, but it must not be supposed that the term "natural" as here used is intended to convey the idea that the examples to which it is applied are correct representations of the subjects regarded ornithologically or botanically, but rather that they are generally drawn with such a close resemblance to the natural object as to place them on the outside limit of decorative art. It may be mentioned here that the selection of subjects for illustration in the present work was not made with any regard to the degree of conventionalism shown, or it would doubtless have been possible to have given examples more strikingly displaying the variety of treatment which they receive at the hands of the Japanese artist. The object was rather to select good examples of work which should give some idea of the range covered by the decorative work of the Japanese, and the skill with which it is executed.

That much of the Japanese decorative work is deliberately conventional cannot of course be doubted, and much of this has unquestionable merit; but it is an interesting question whether in their most successful work the artist is not decorative rather by accident than by intent,—whether, in fact, he has not striven to produce a faithful and life-like copy of nature, and fallen just so far short of reaching a pictorial standard as to produce a decorative effect. That notwithstanding their love of nature and constant artistic reproduction of some of her features during many centuries they have hitherto failed to produce any pictorial illustrations, even of birds or flowers which are ornithologically or botanically correct, is the opinion of many of those who have a wide acquaintance with their works. As to the correctness of this view, and many other important points, we shall doubtless arrive at some definite conclusion when we obtain a more accurate knowledge of the Art history of this interesting people, upon which subject a promised work from the hands of the eminent authorities, Messrs. W. Anderson and E. Satow, is looked for with much interest by all students of Japanese Art.

PLATES

PLATE 1

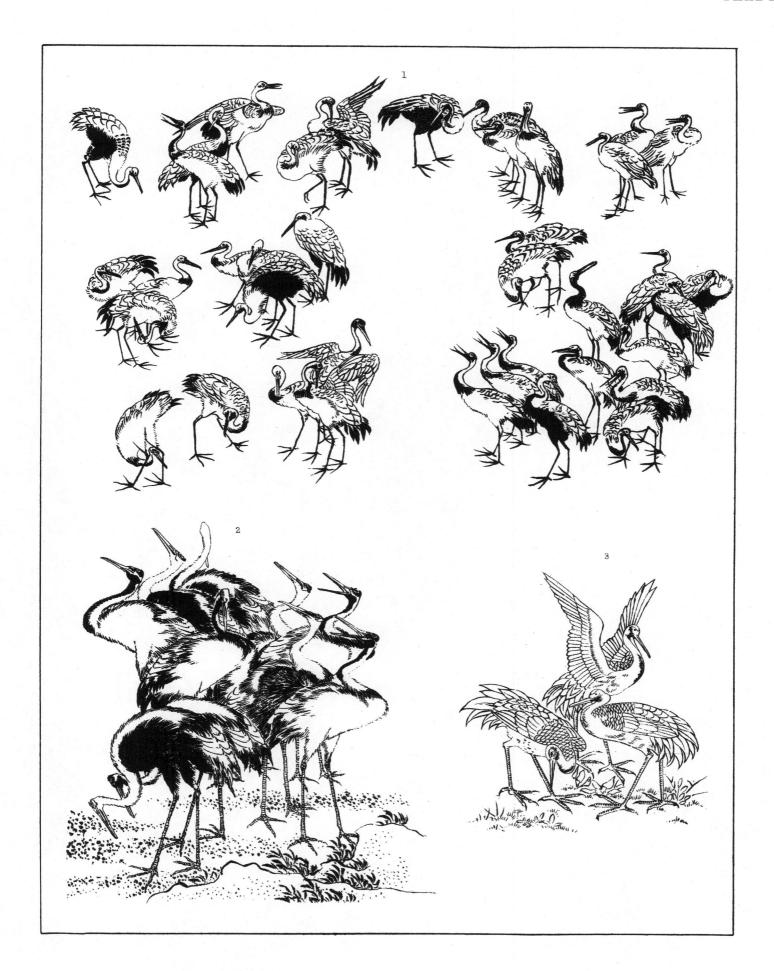

PLATE 2

PLATE 3

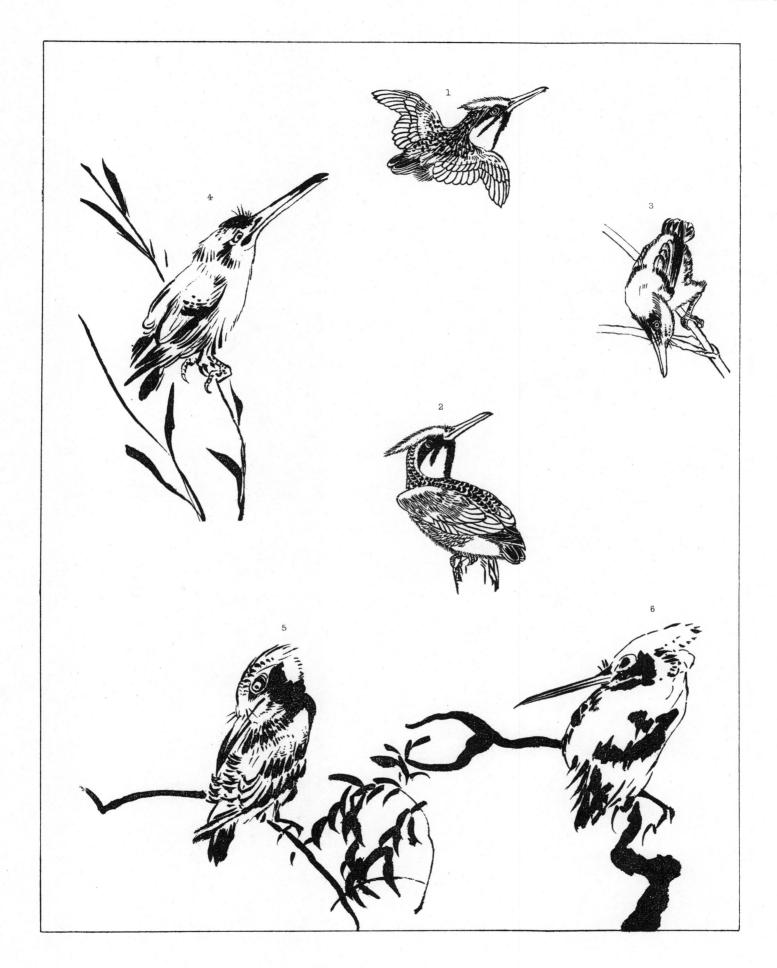

PLATE 4

PLATE 5

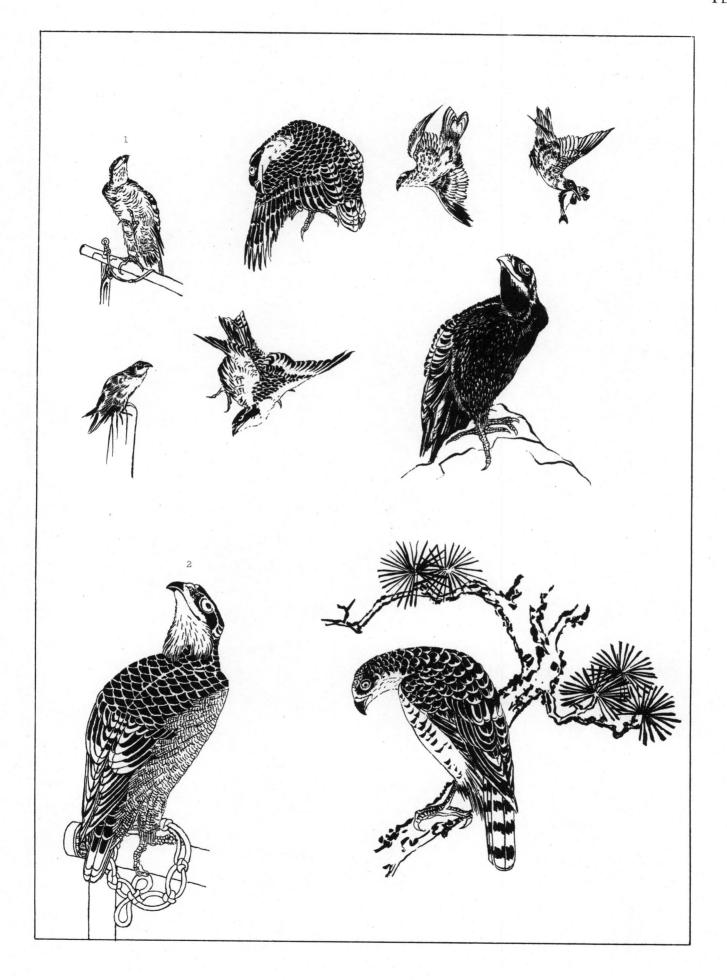

PLATE 6

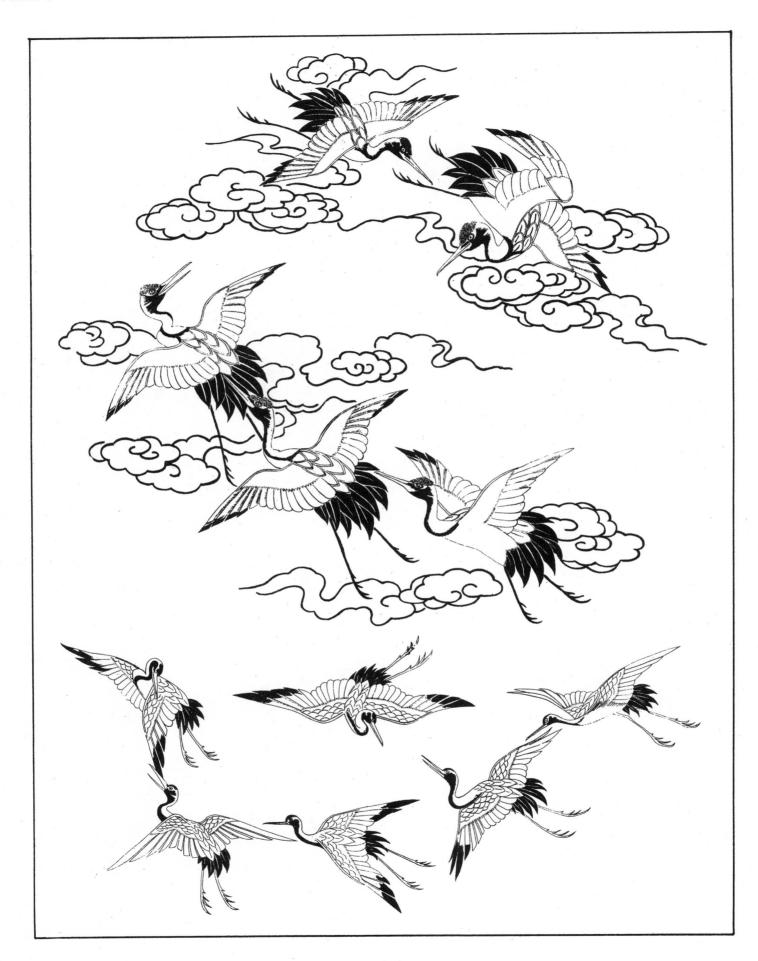

PLATE 7

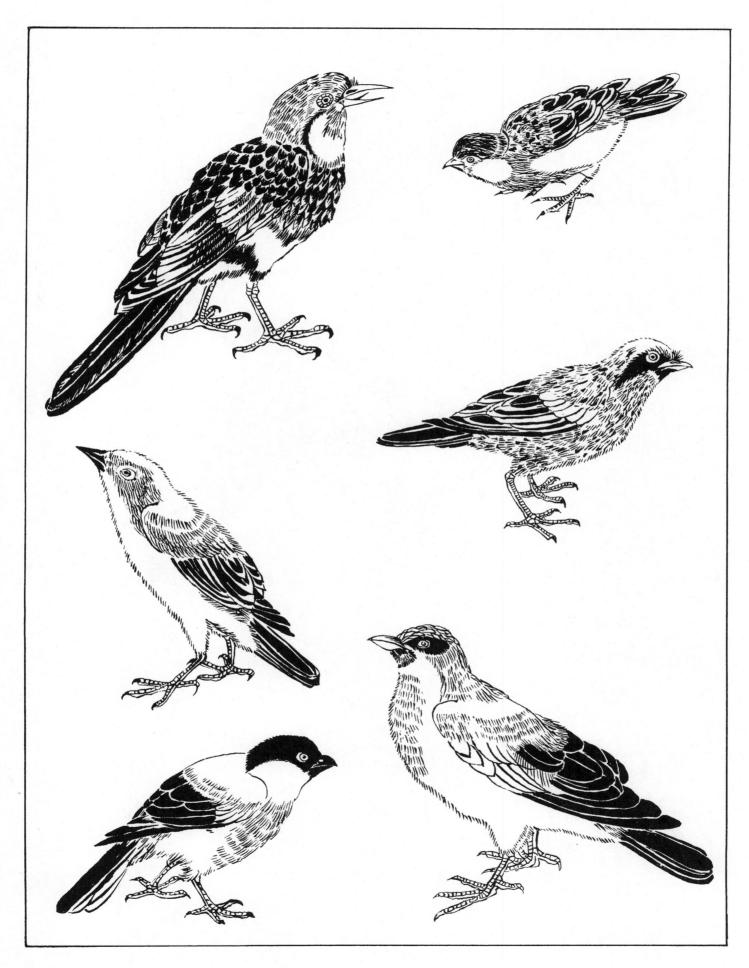

PLATE 8

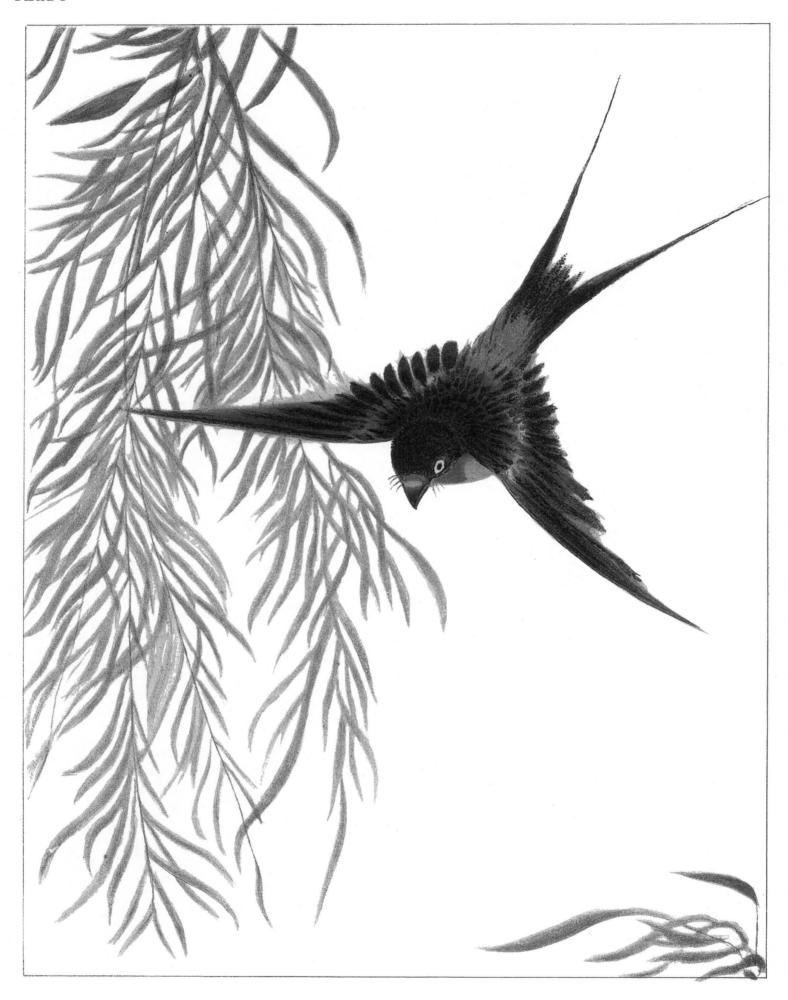

PLATE 9

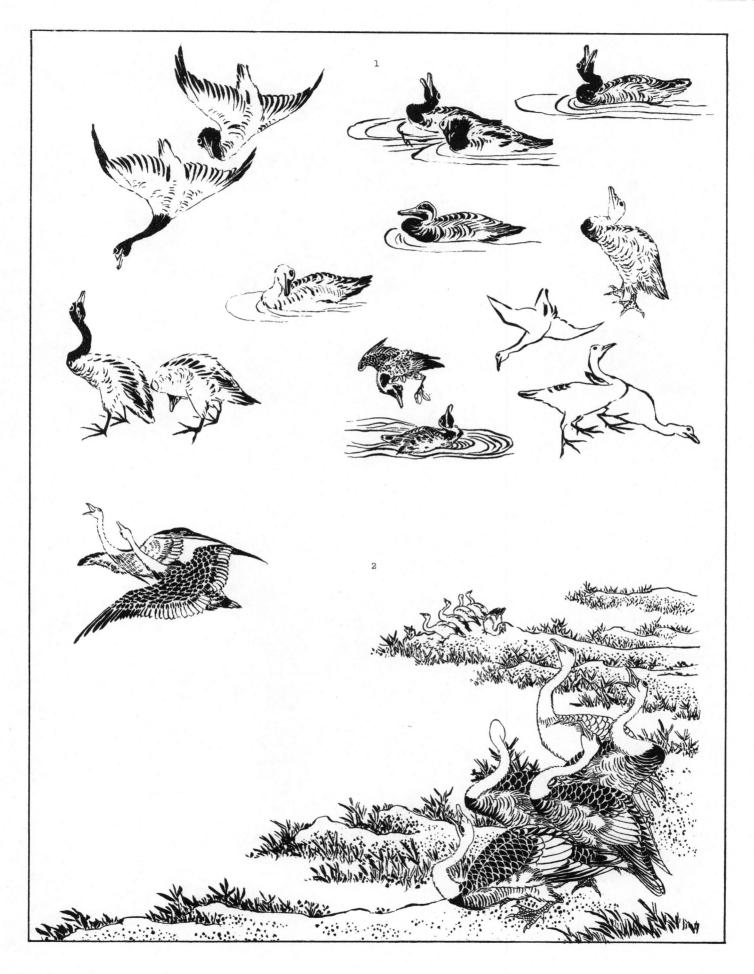

PLATE 10

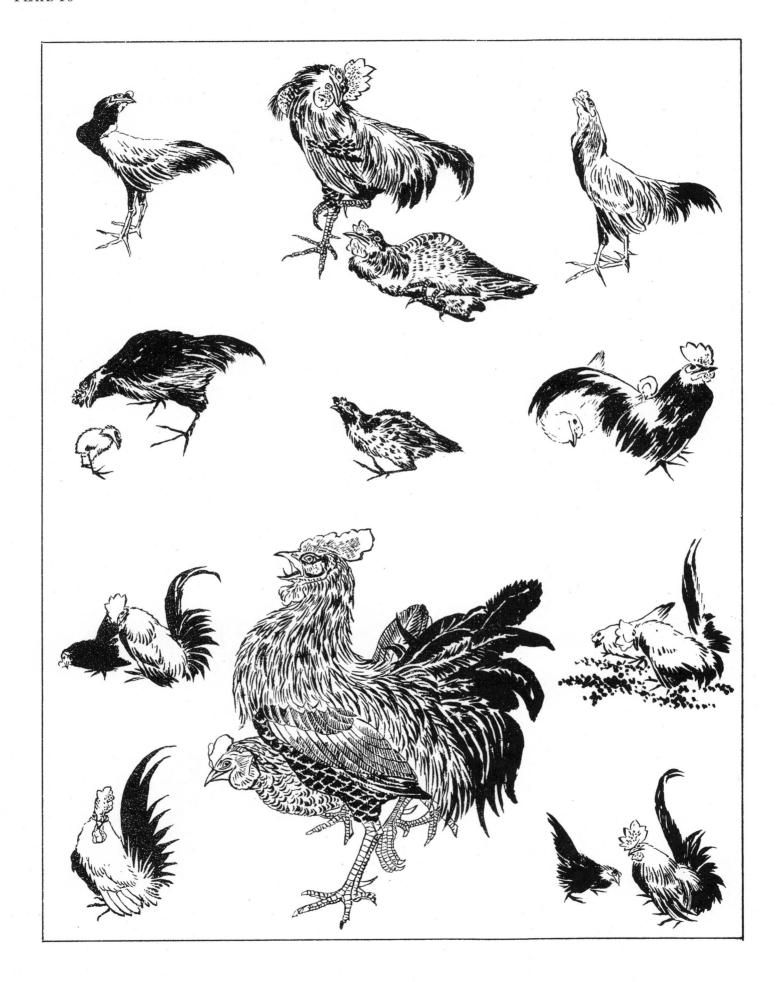

PLATE 11

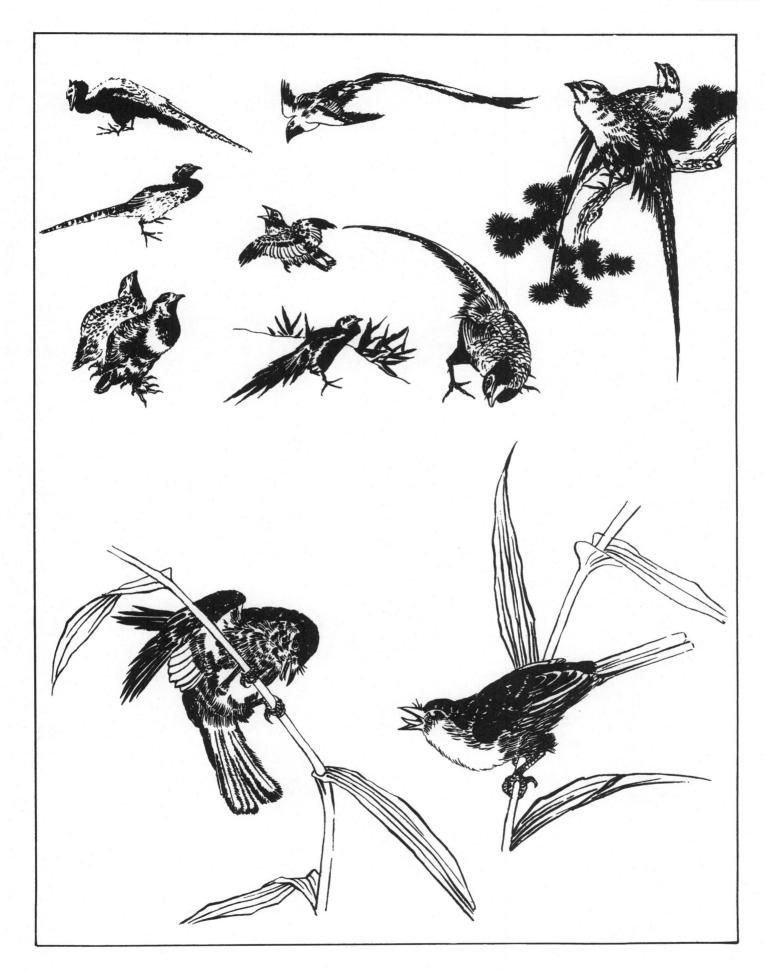

PLATE 12

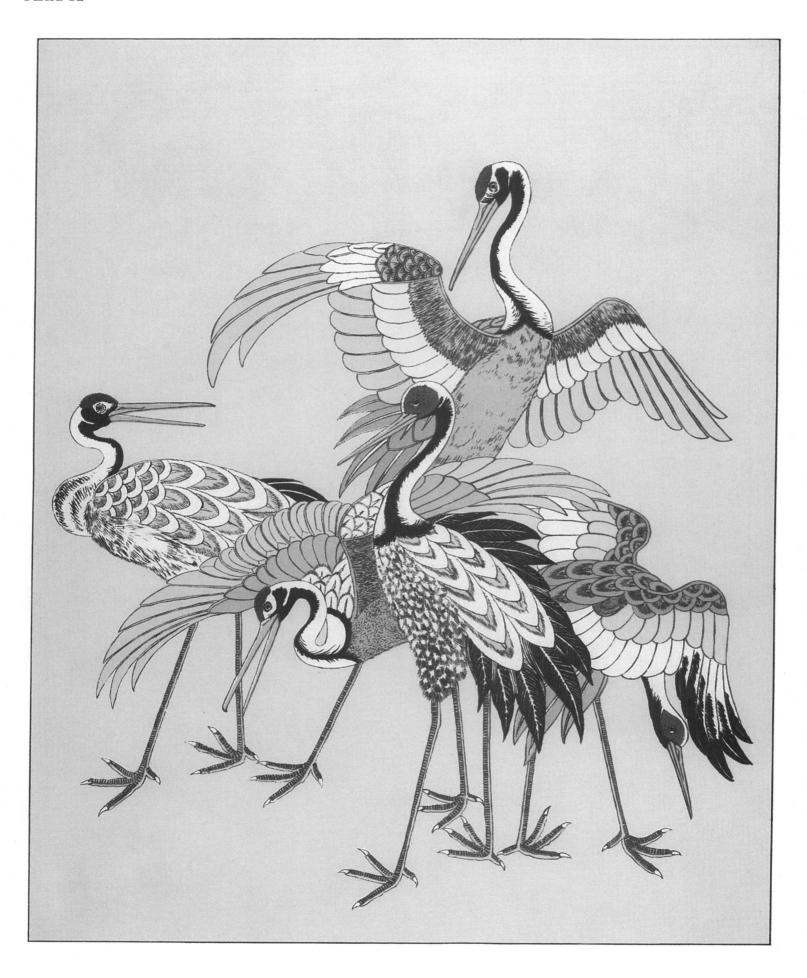

PLATE 13

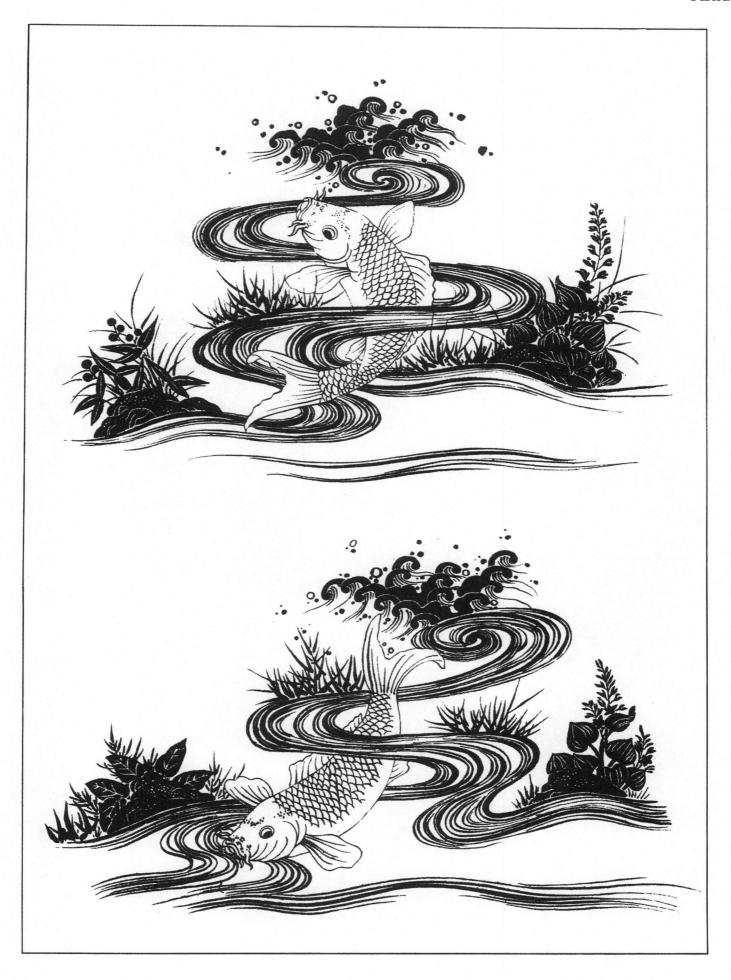

PLATE 14

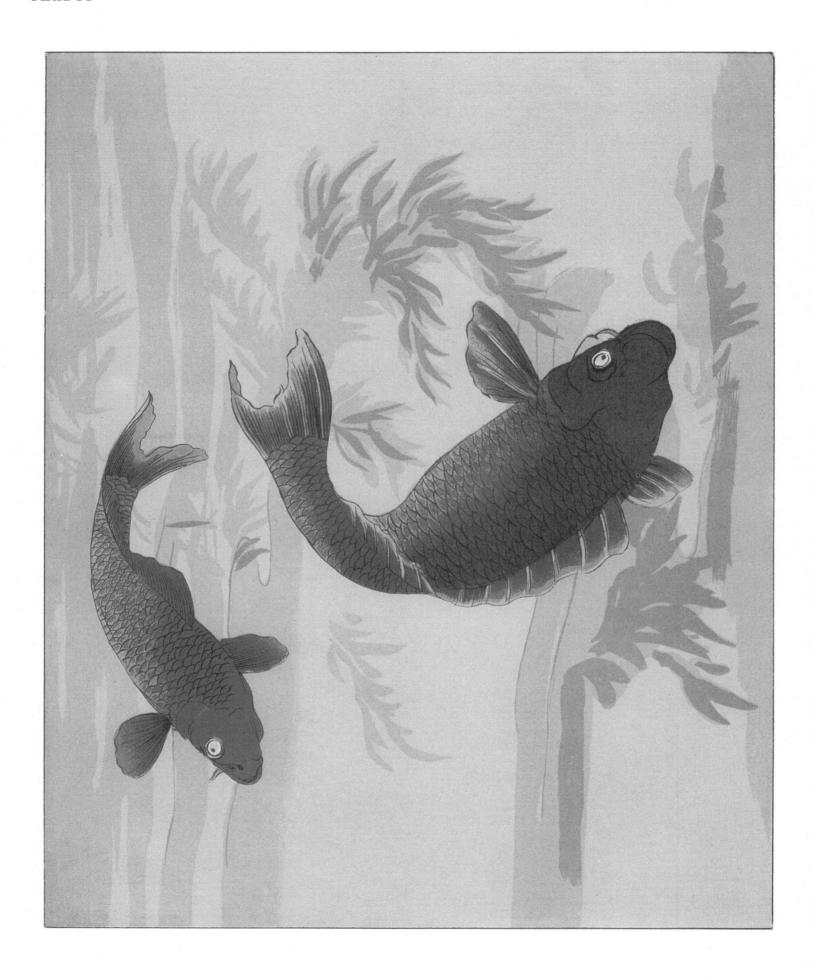

PLATE 15

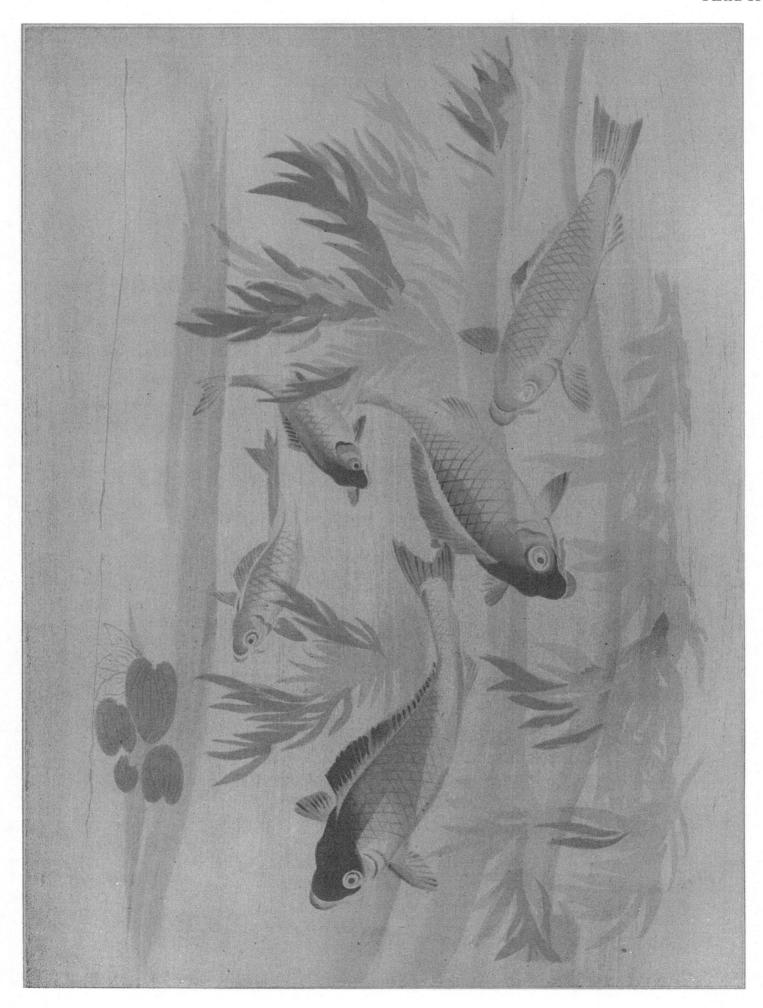

PLATE 16

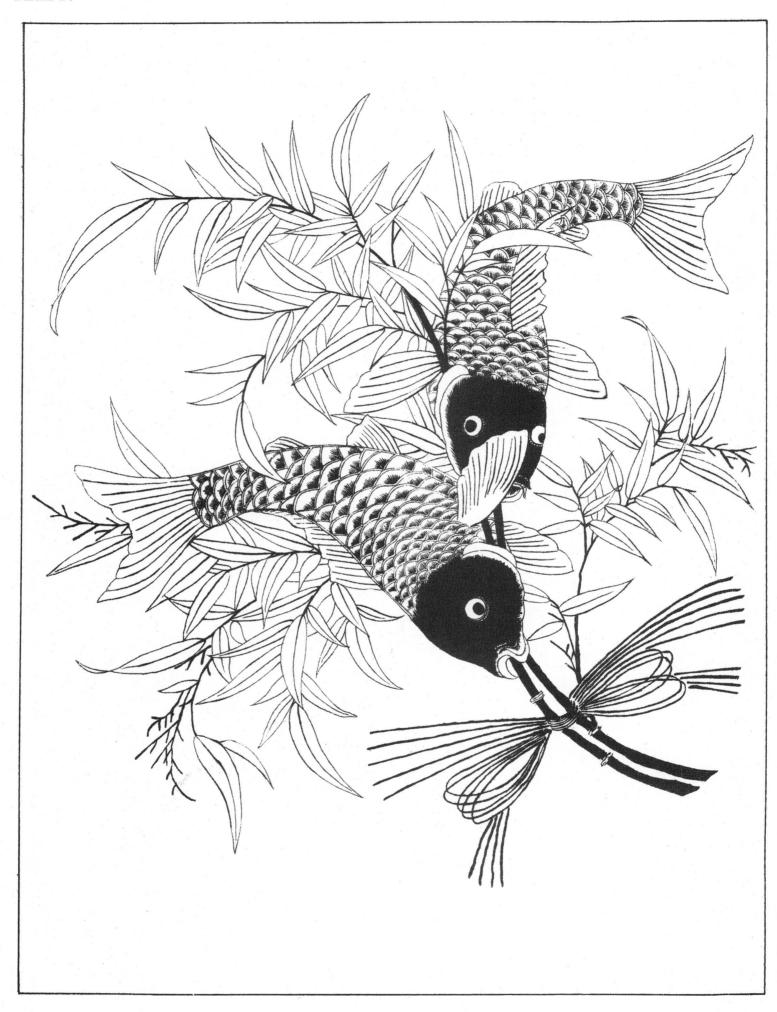

PLATE 17

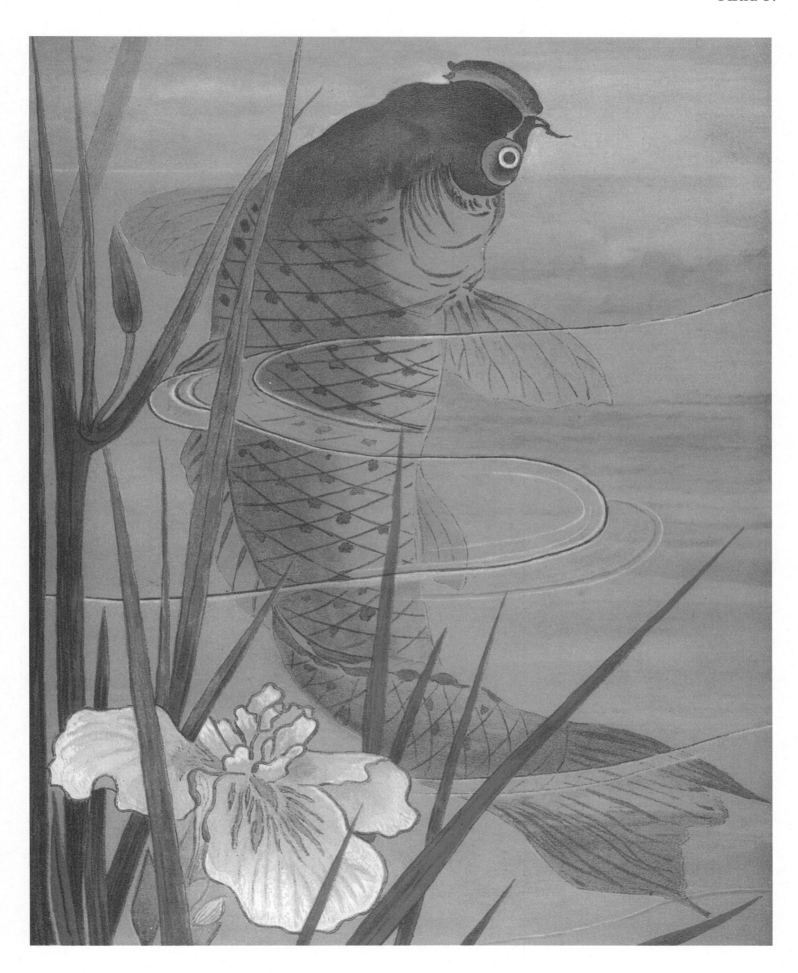

PLATE 18

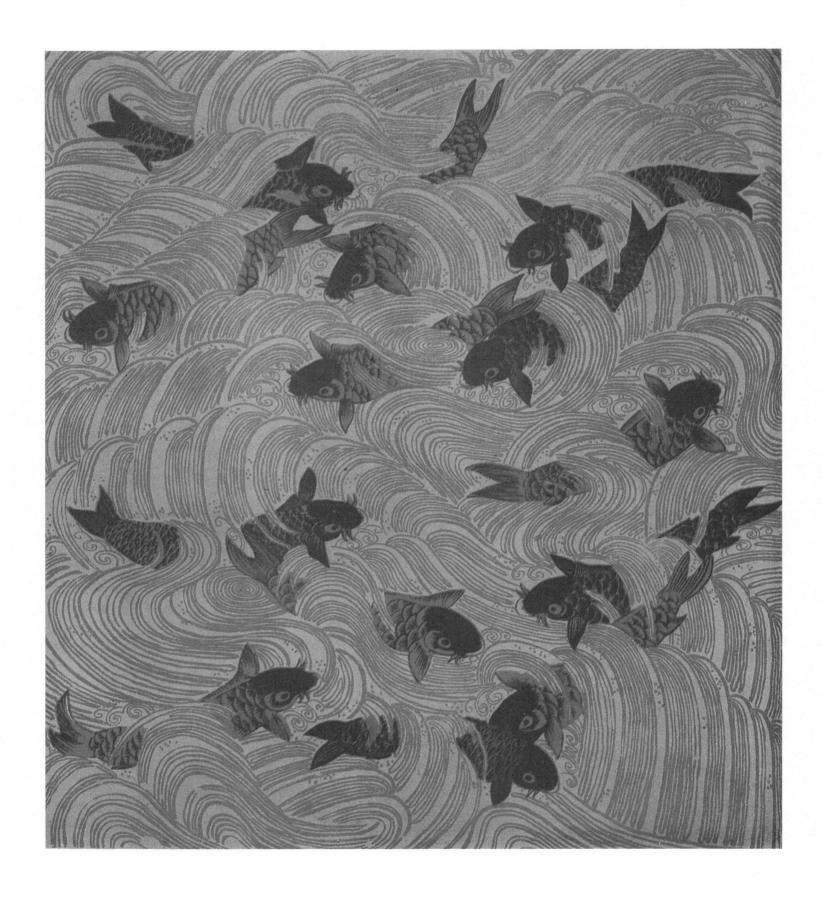

PLATE 19

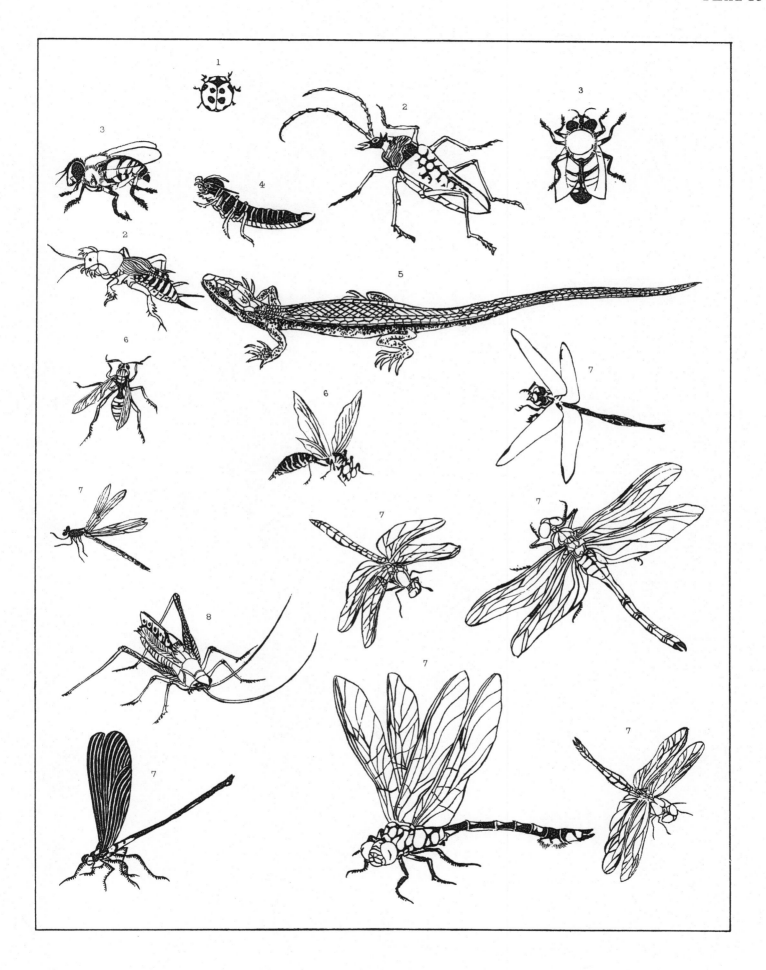

PLATE 20

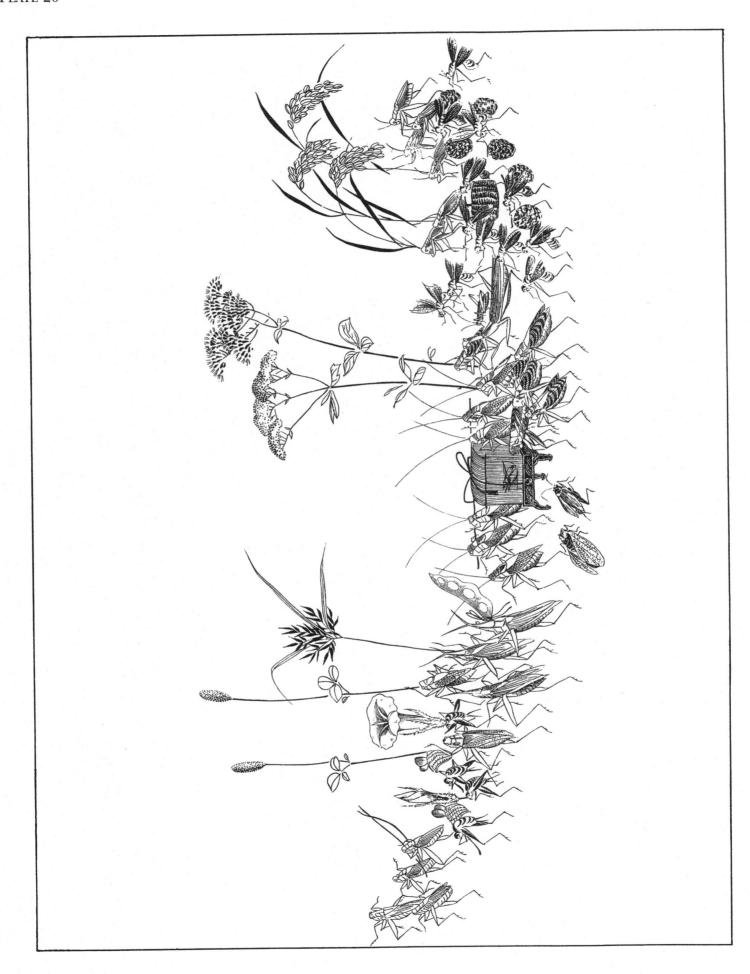

PLATE 21

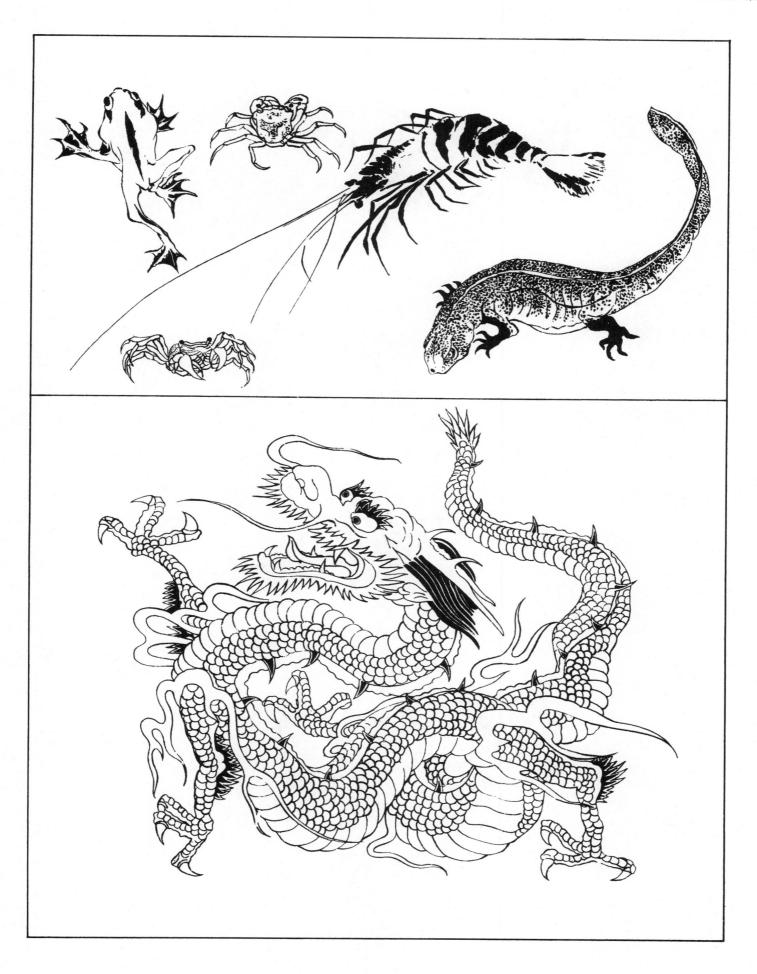

PLATE 22

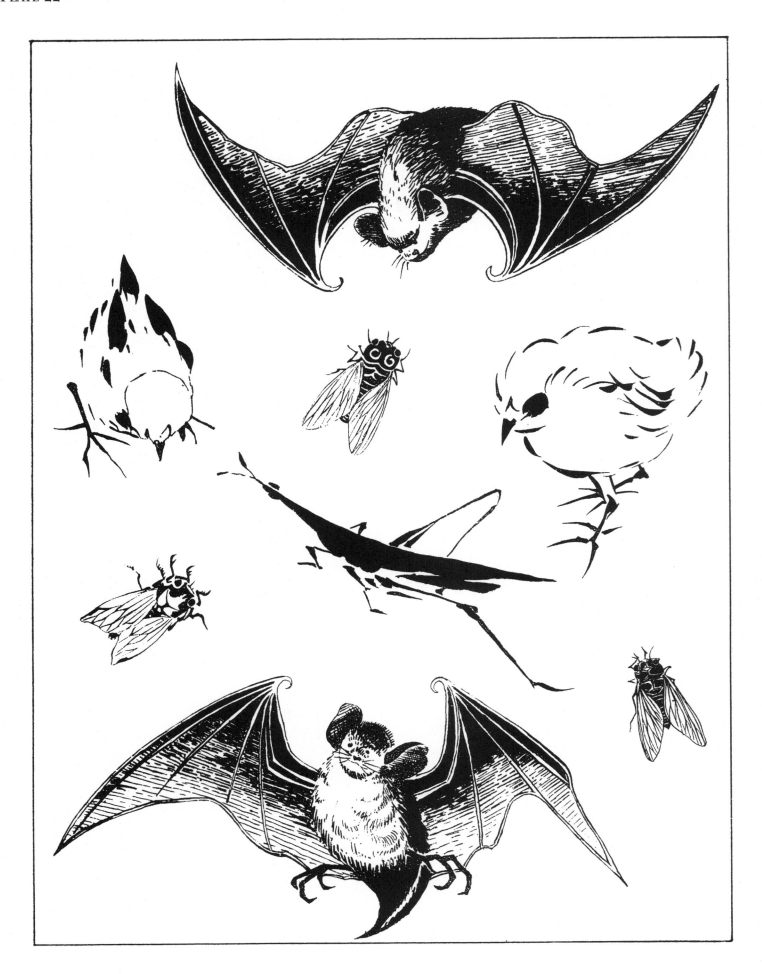

PLATE 23

PLATE 24

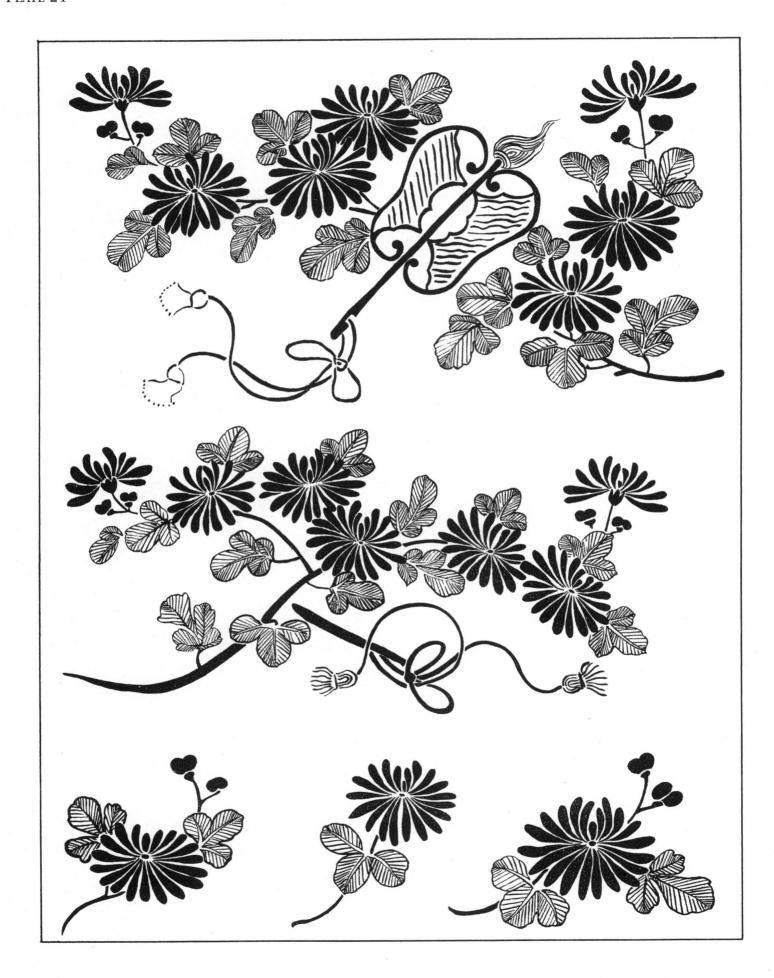

PLATE 25

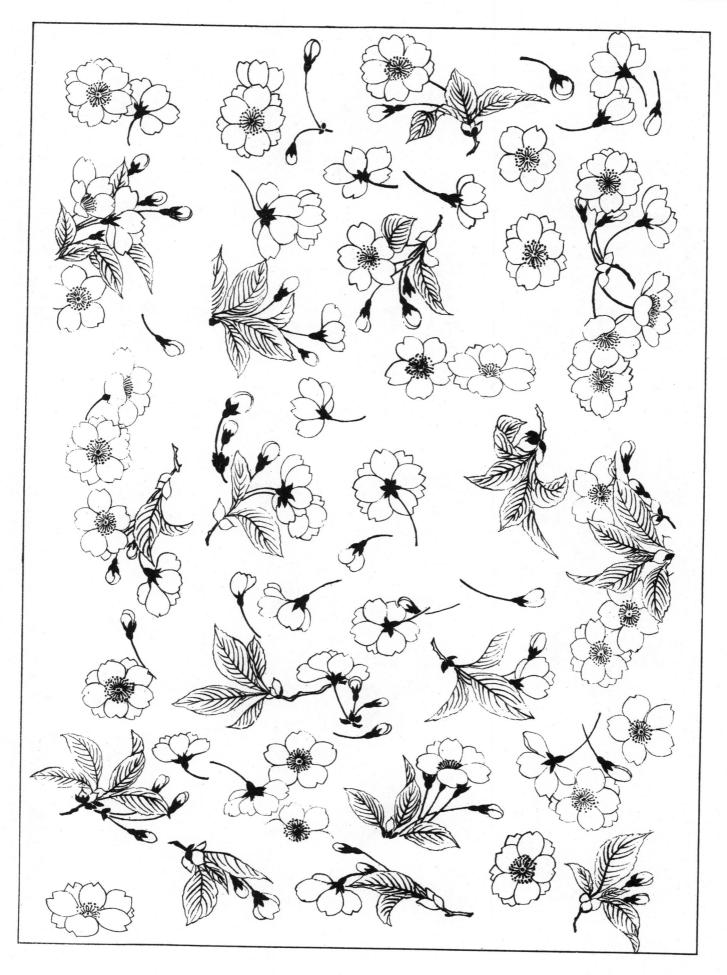

PLATE 26

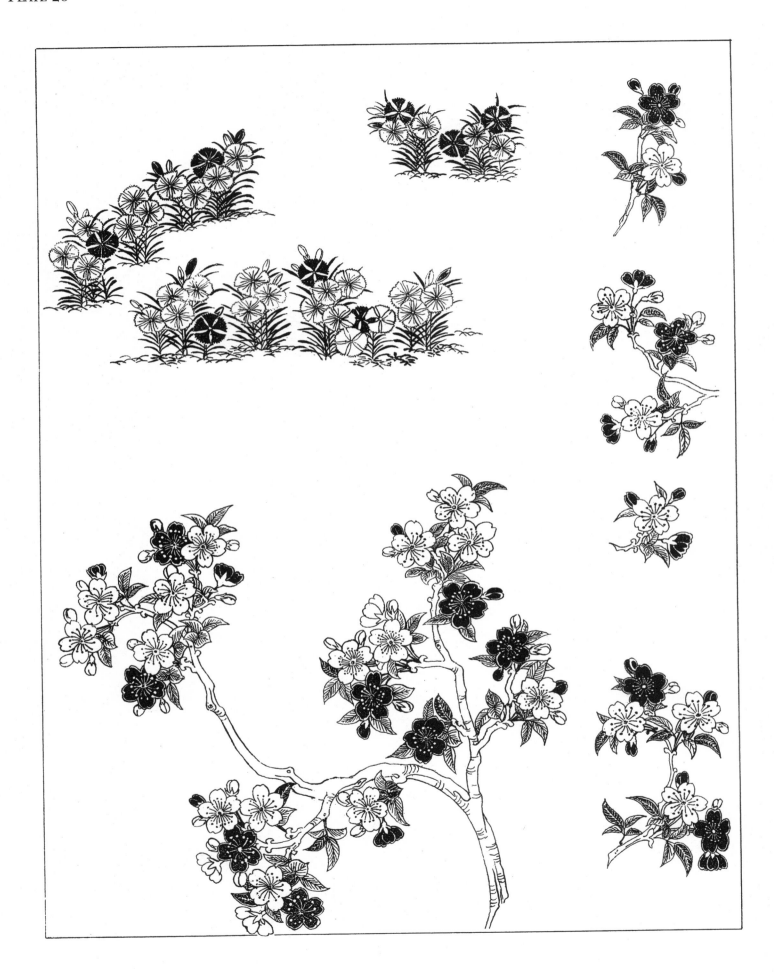

PLATE 27

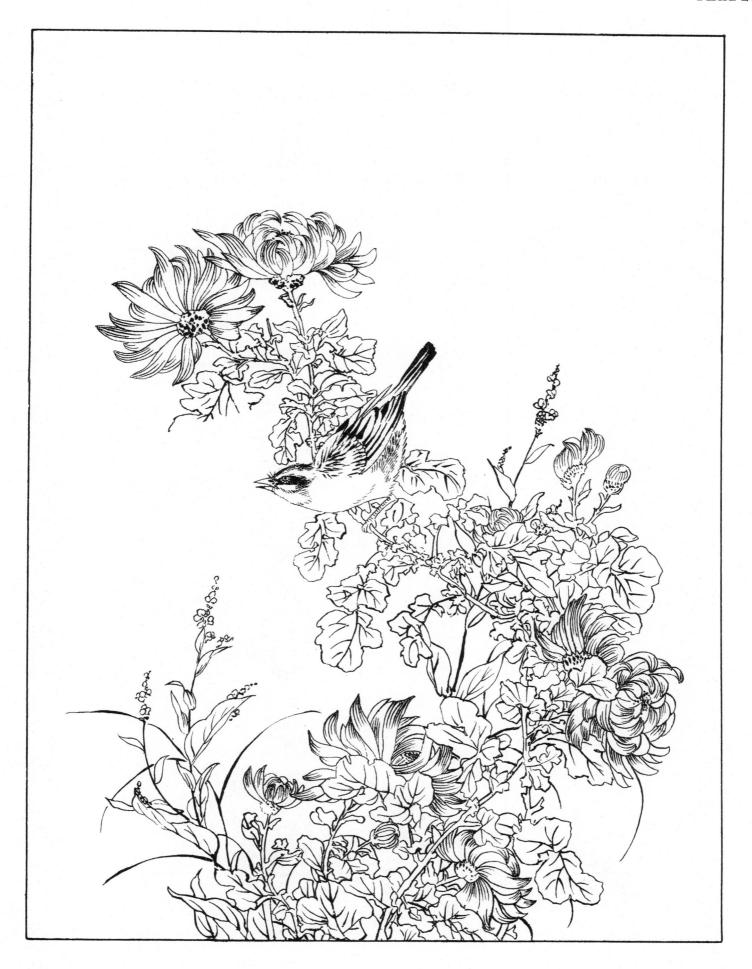

PLATE 28

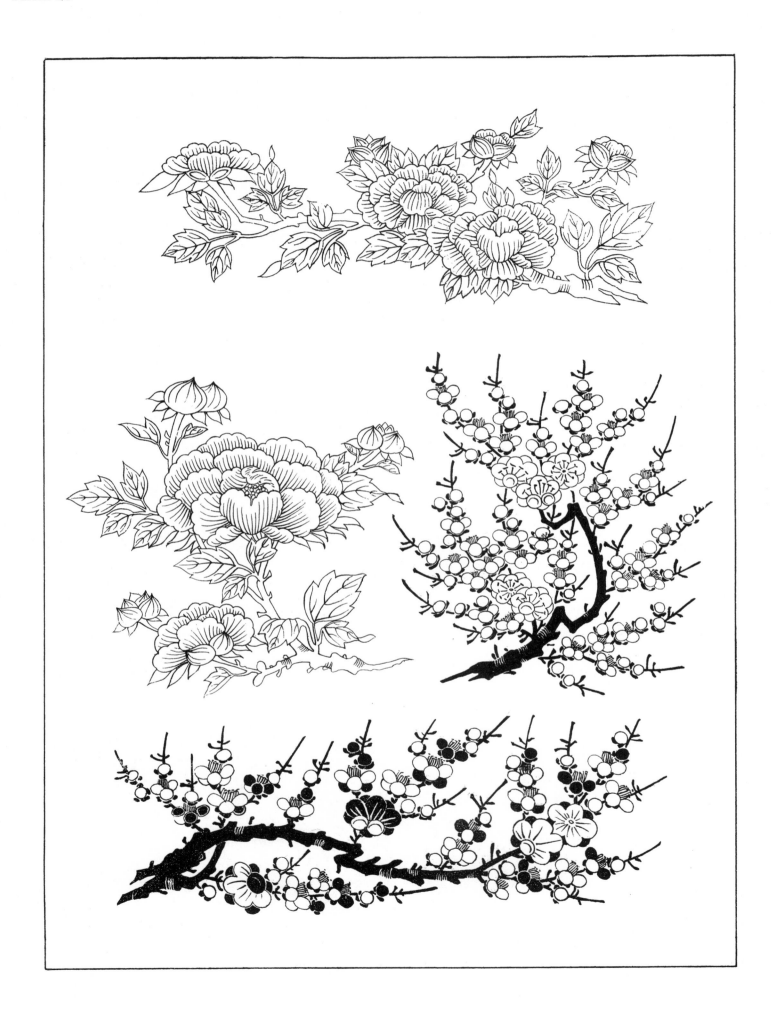

PLATE 29

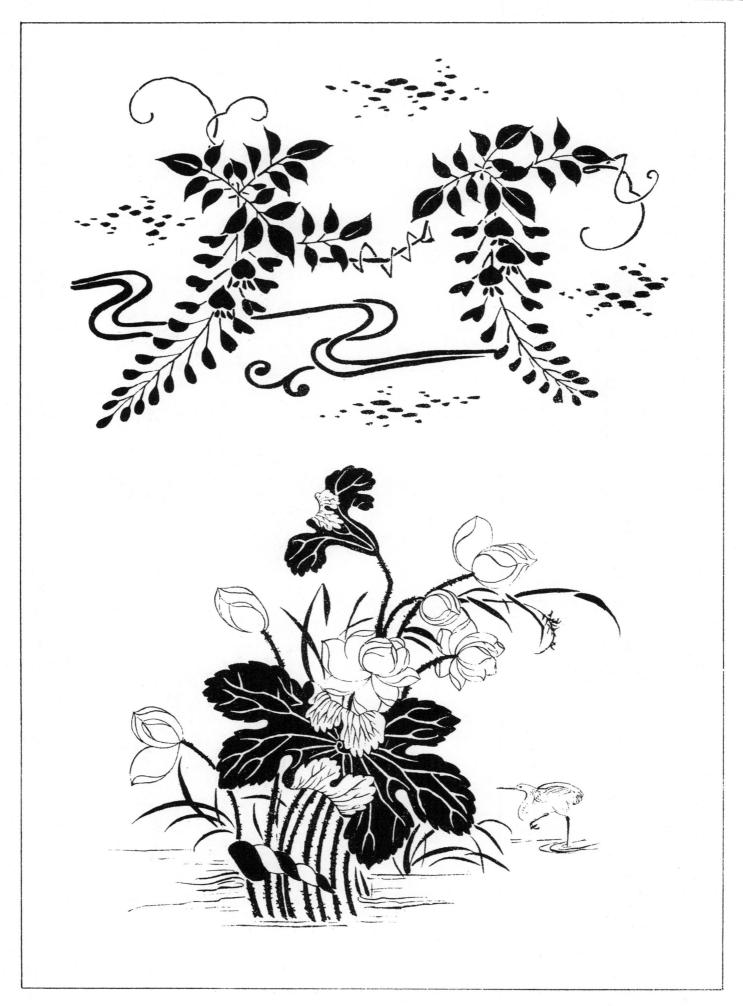

PLATE 30

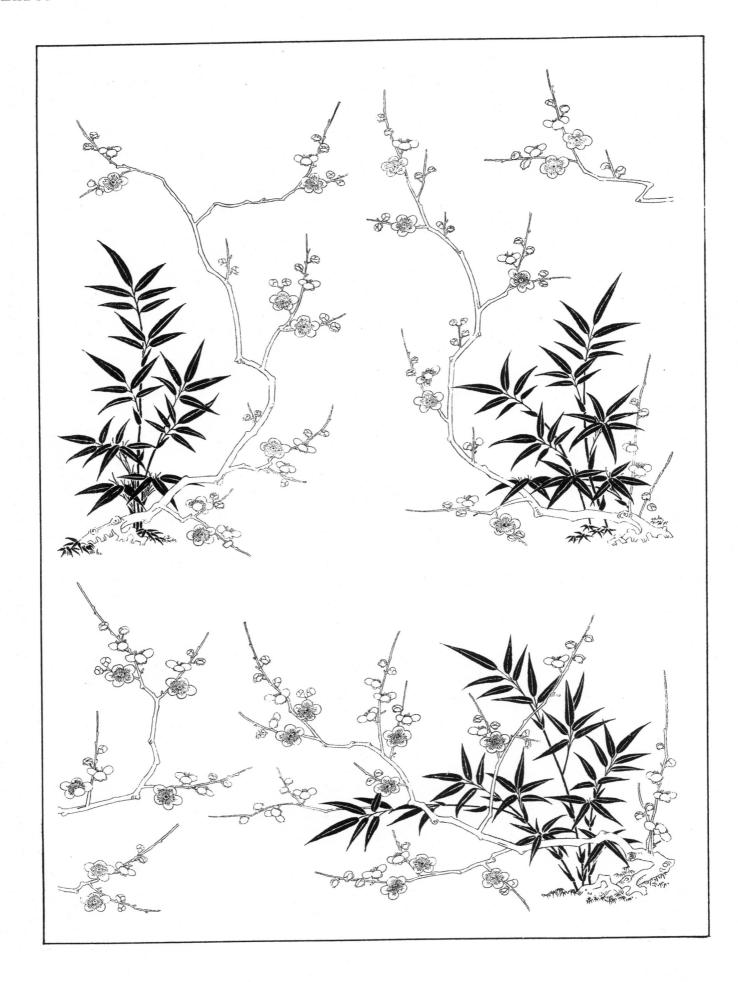

PLATE 31

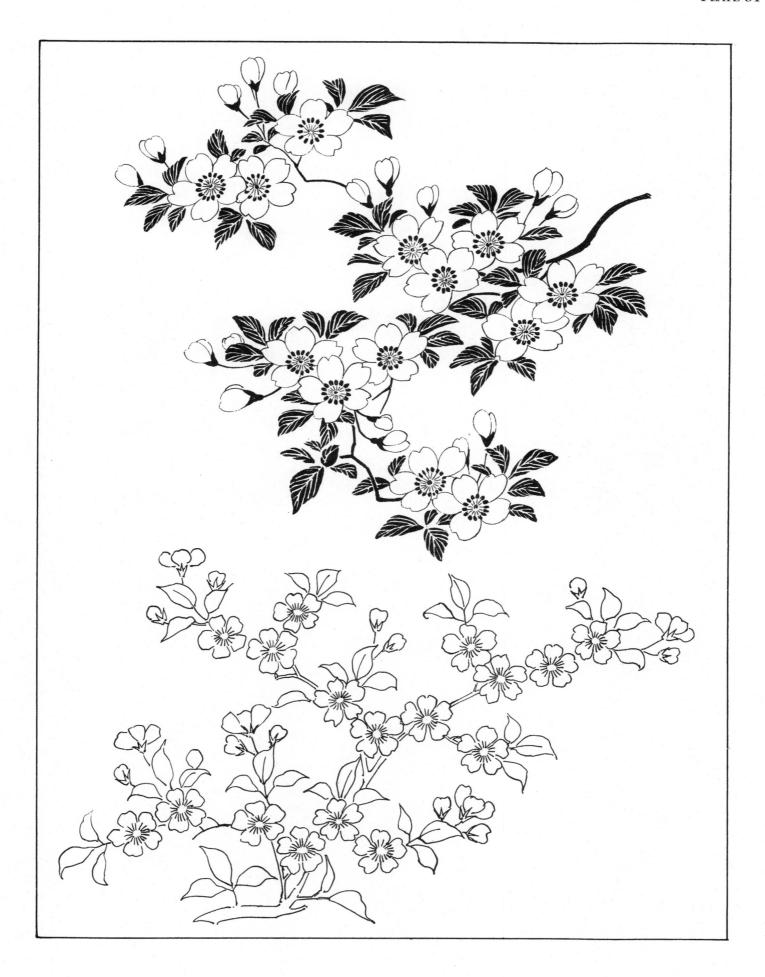

PLATE 32

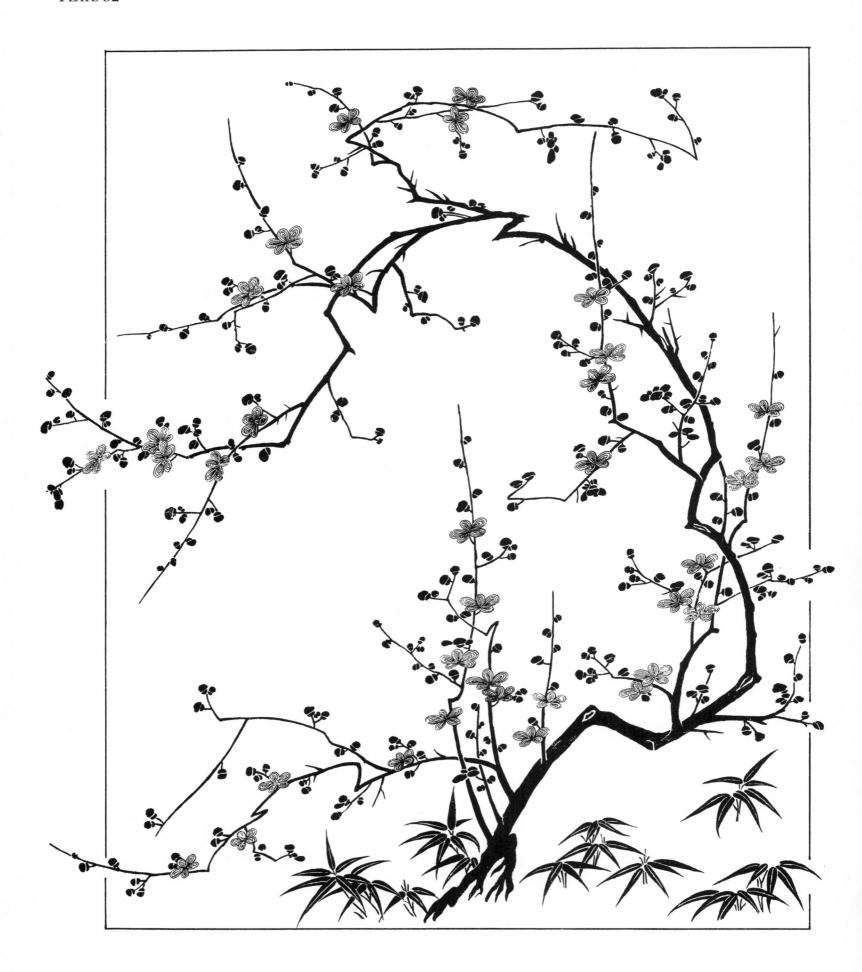

PLATE 33

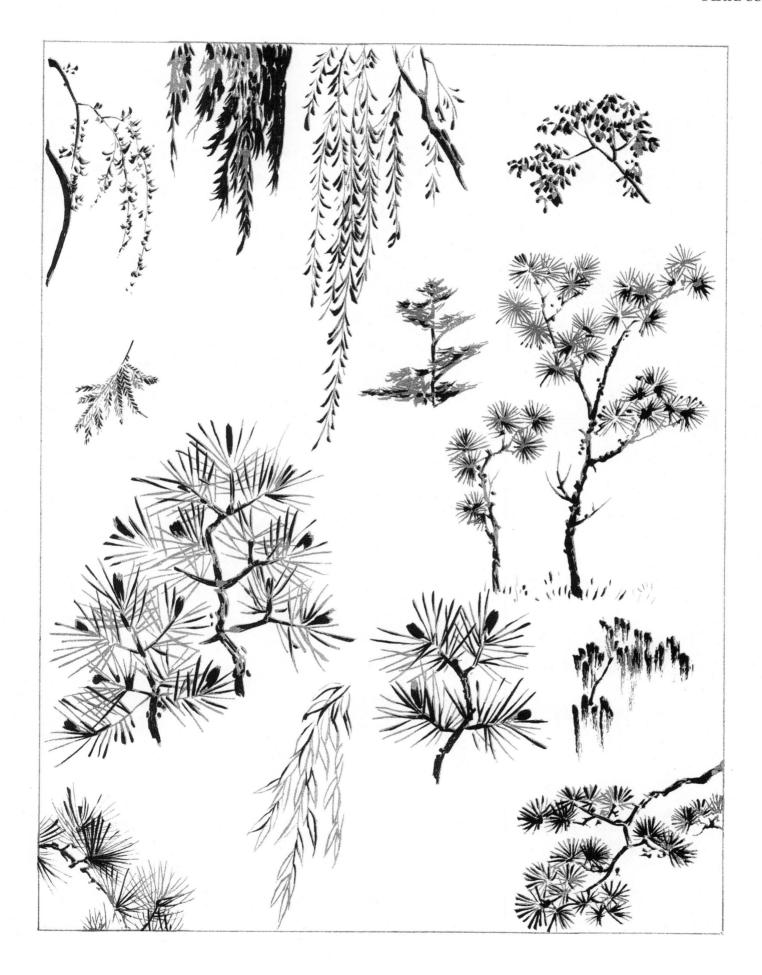

PLATE 34

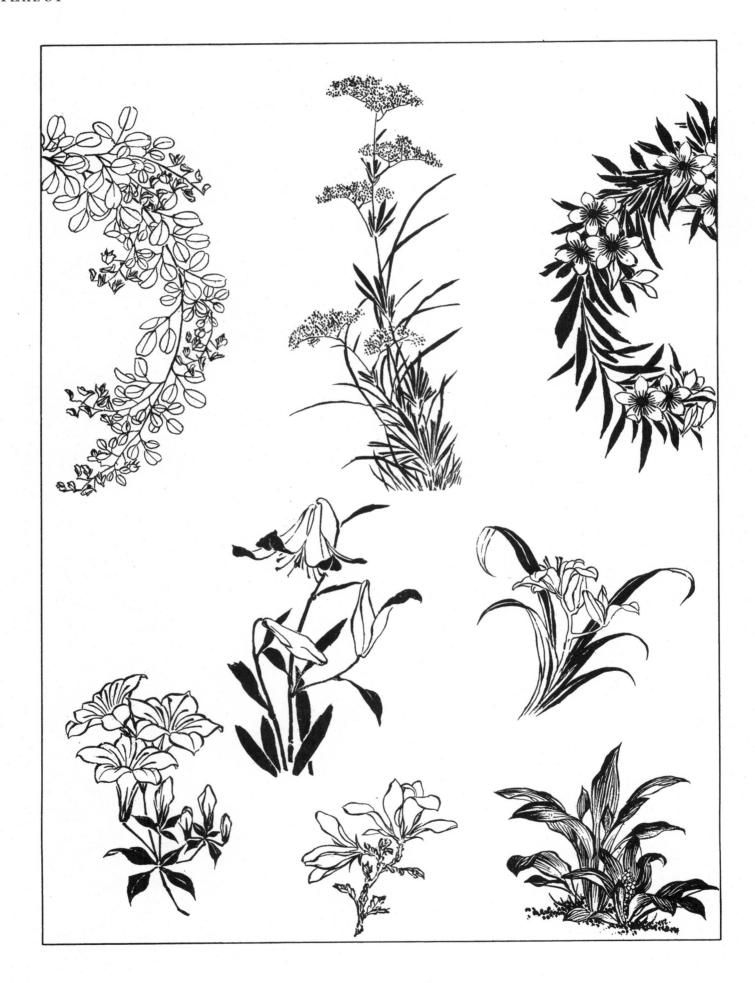

PLATE 35

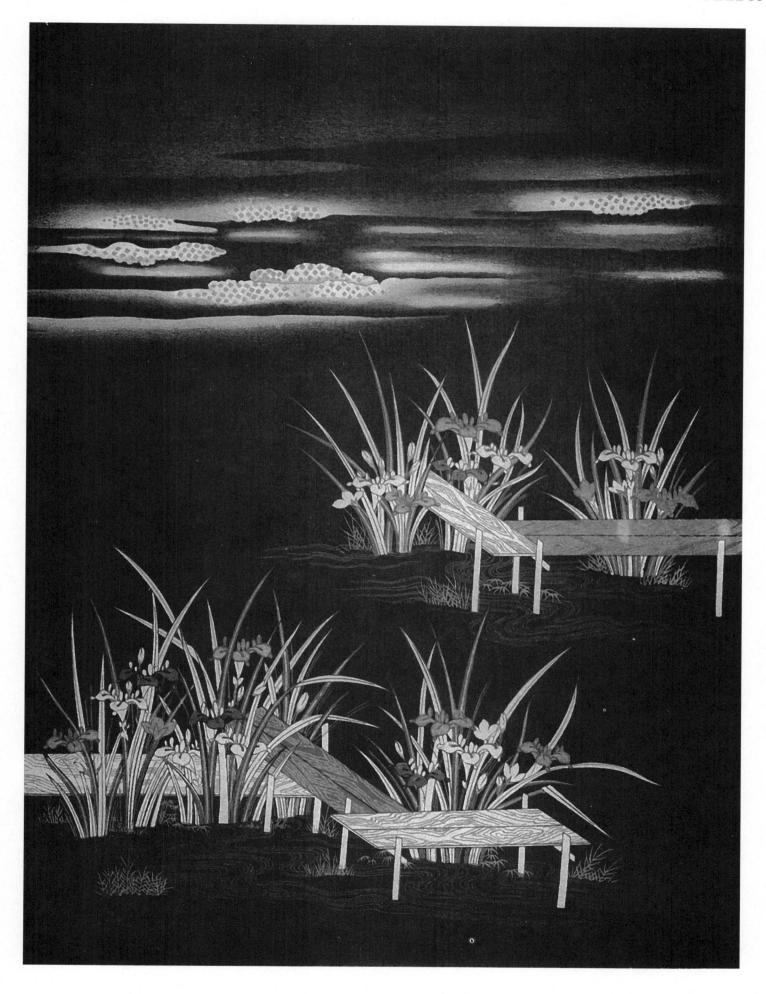

PLATE 36

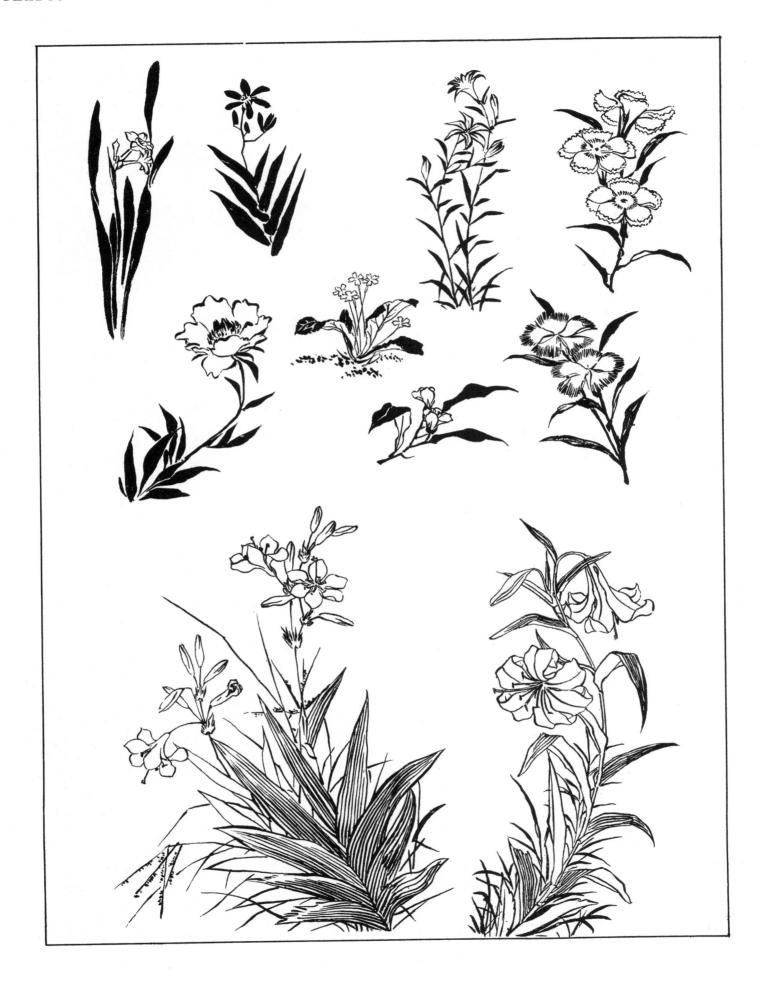

PLATE 37

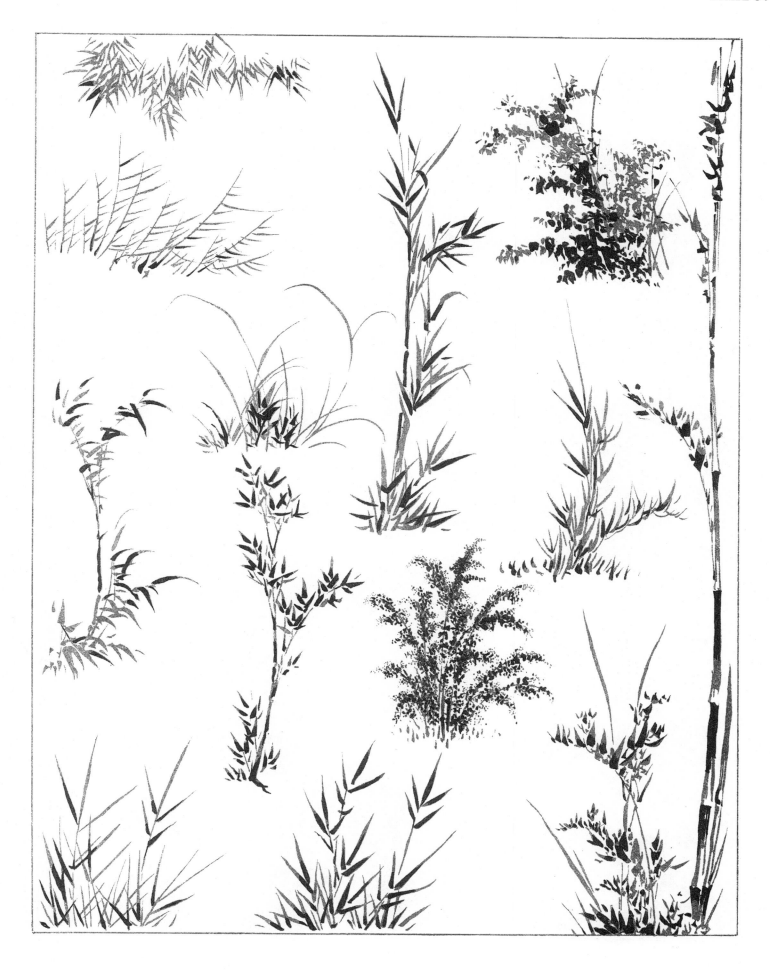

PLATE 38

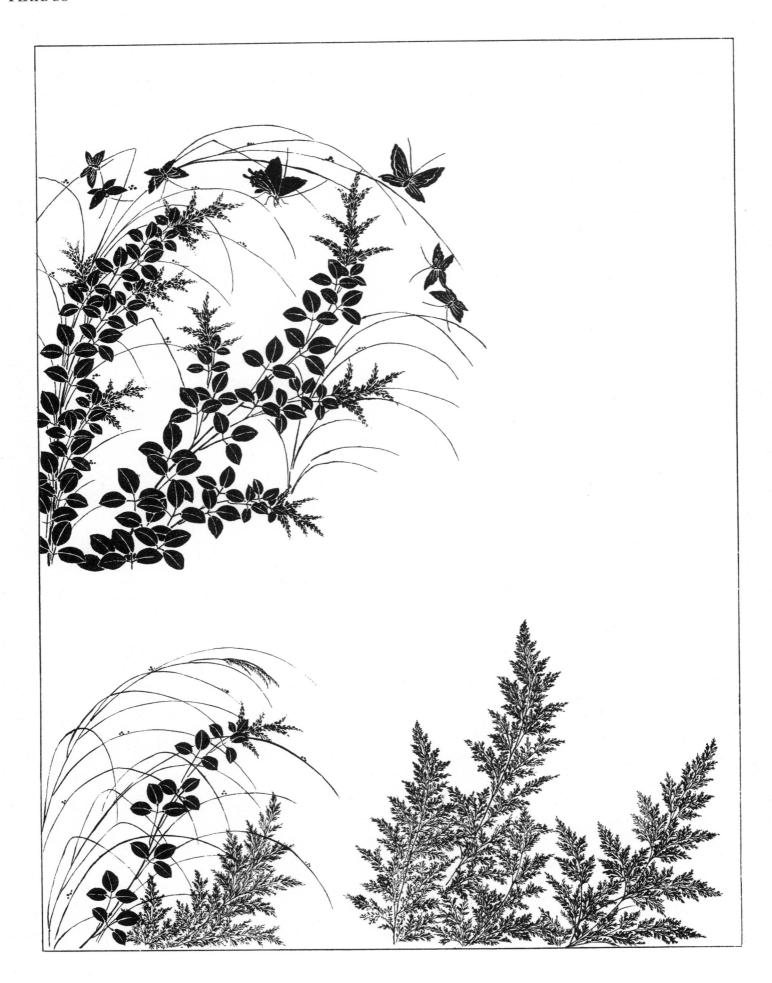

PLATE 39

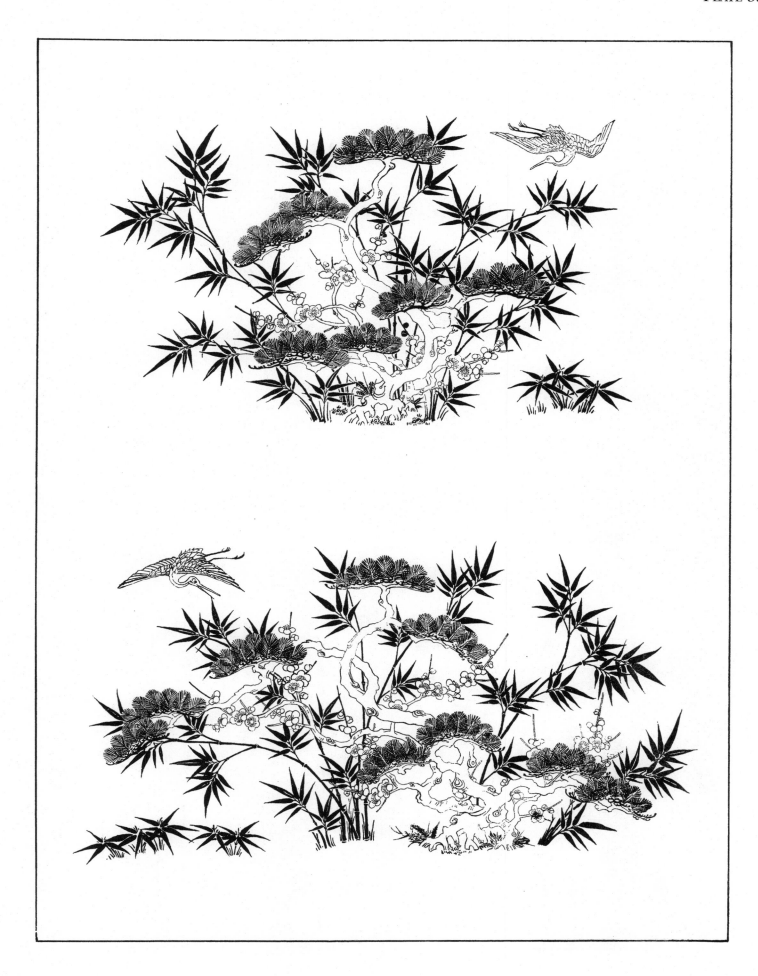

PLATE 40

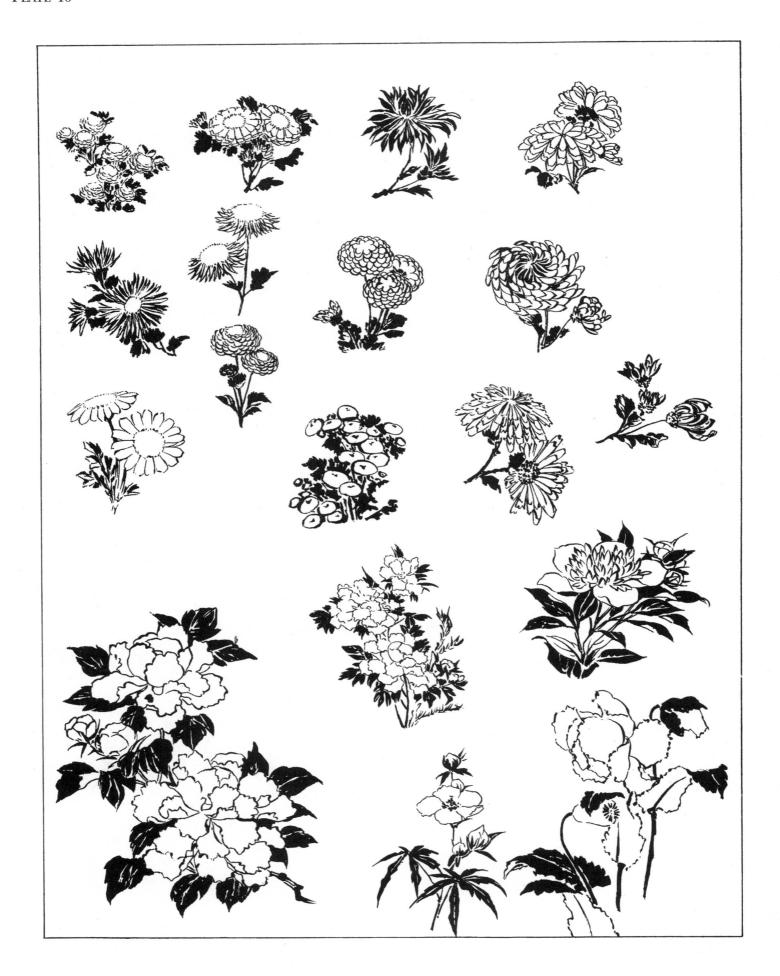

PLATE 41

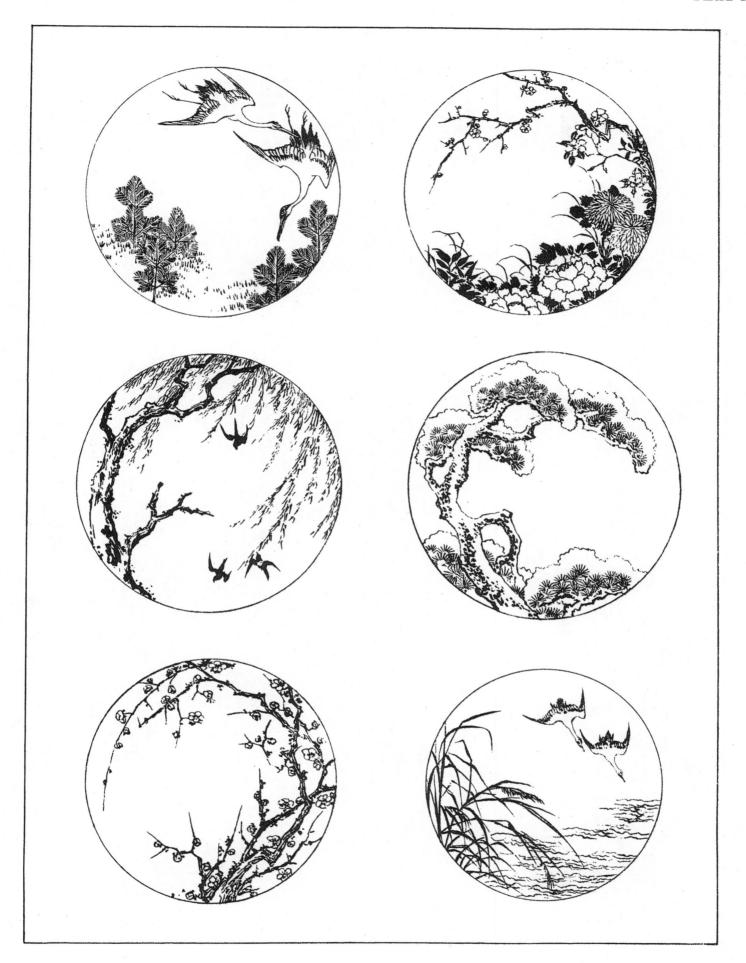

PLATE 42

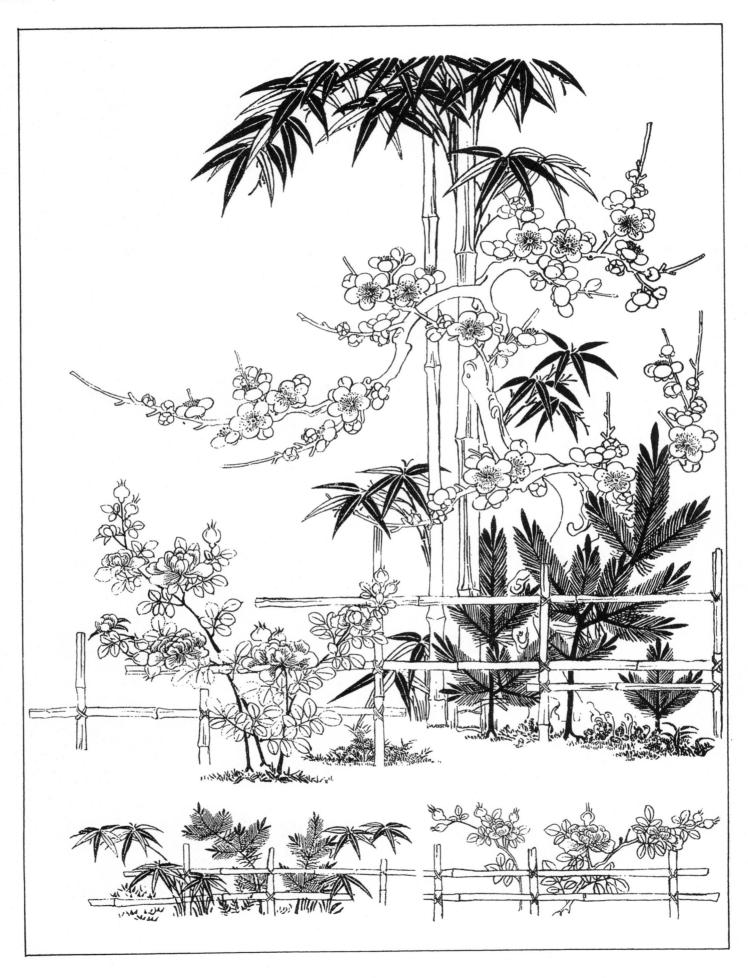

PLATE 43

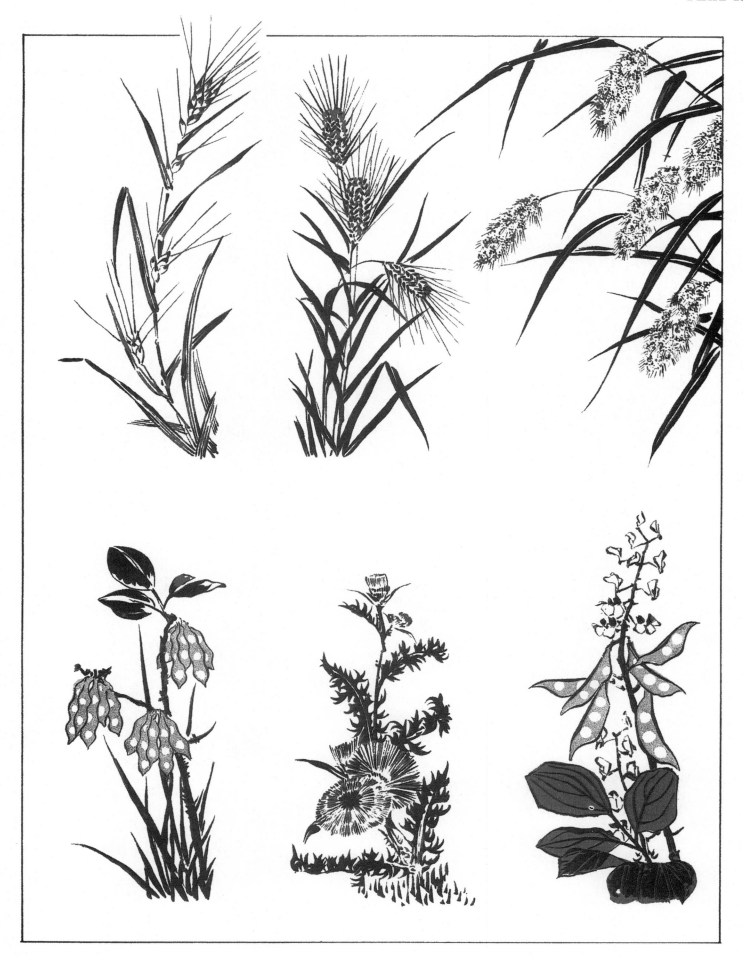

PLATE 44

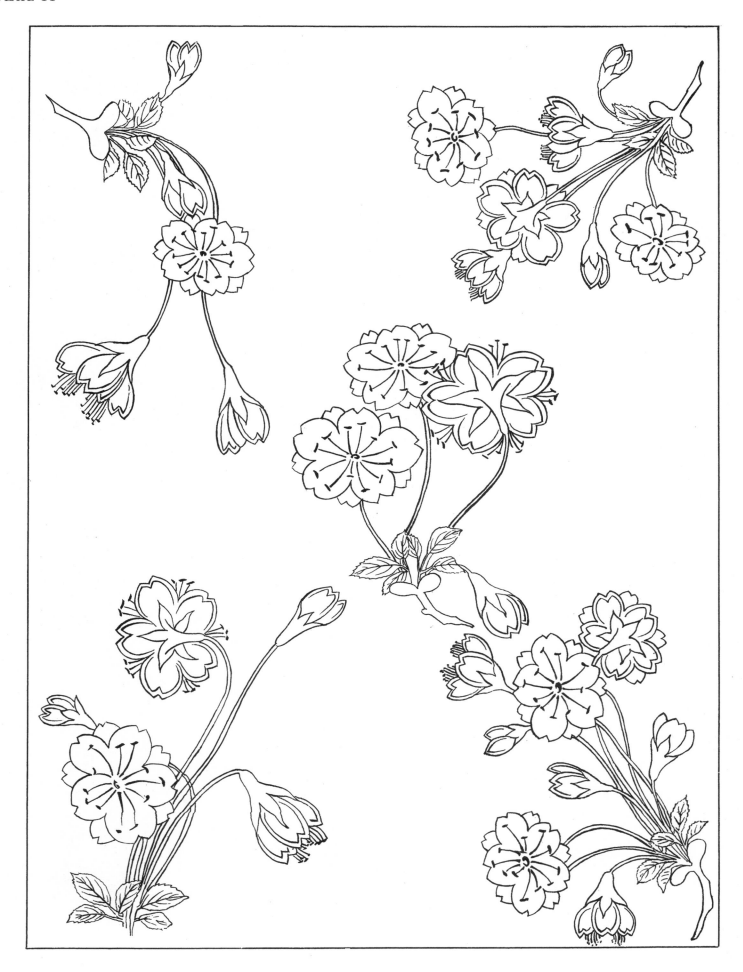

PLATE 45

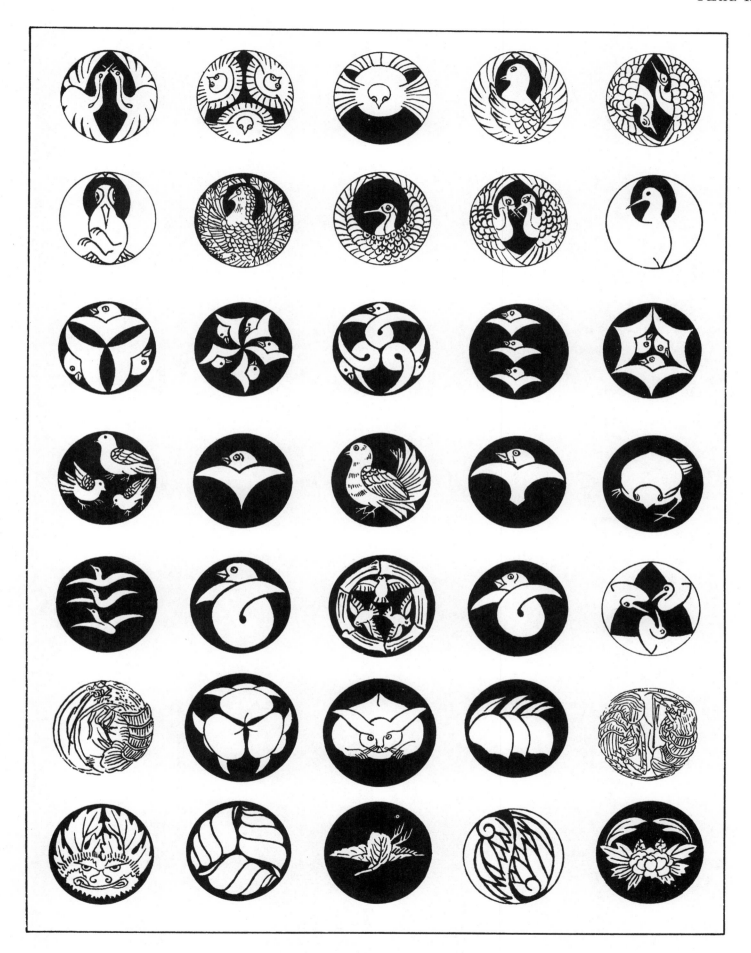

PLATE 46

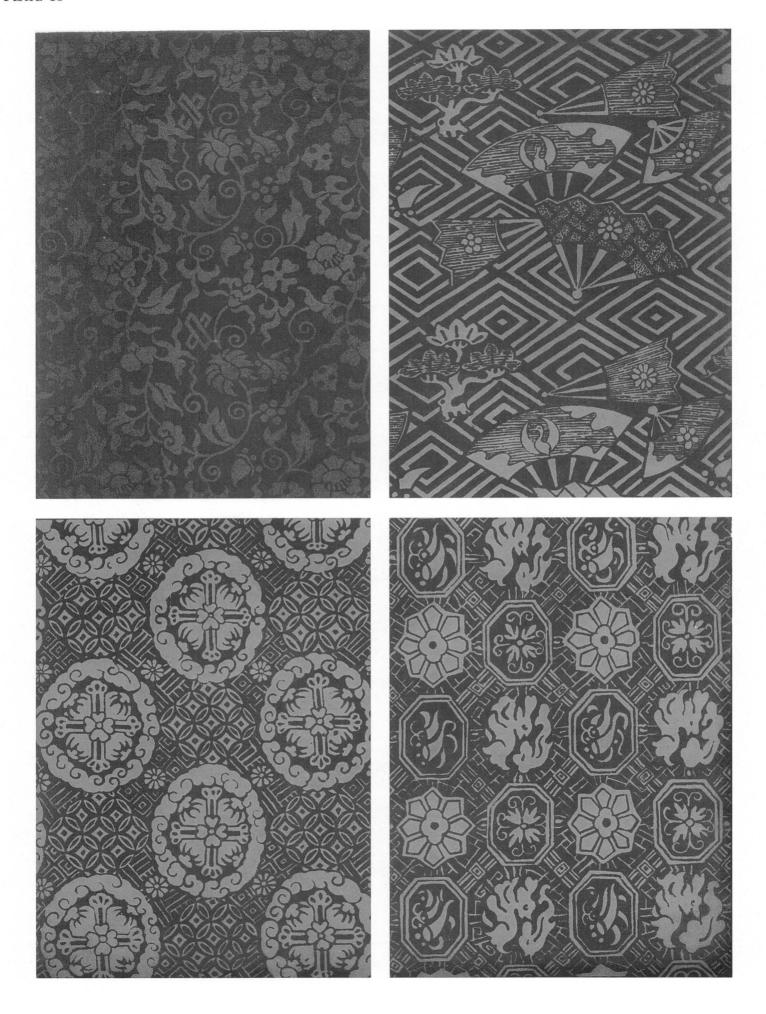

PLATE 47

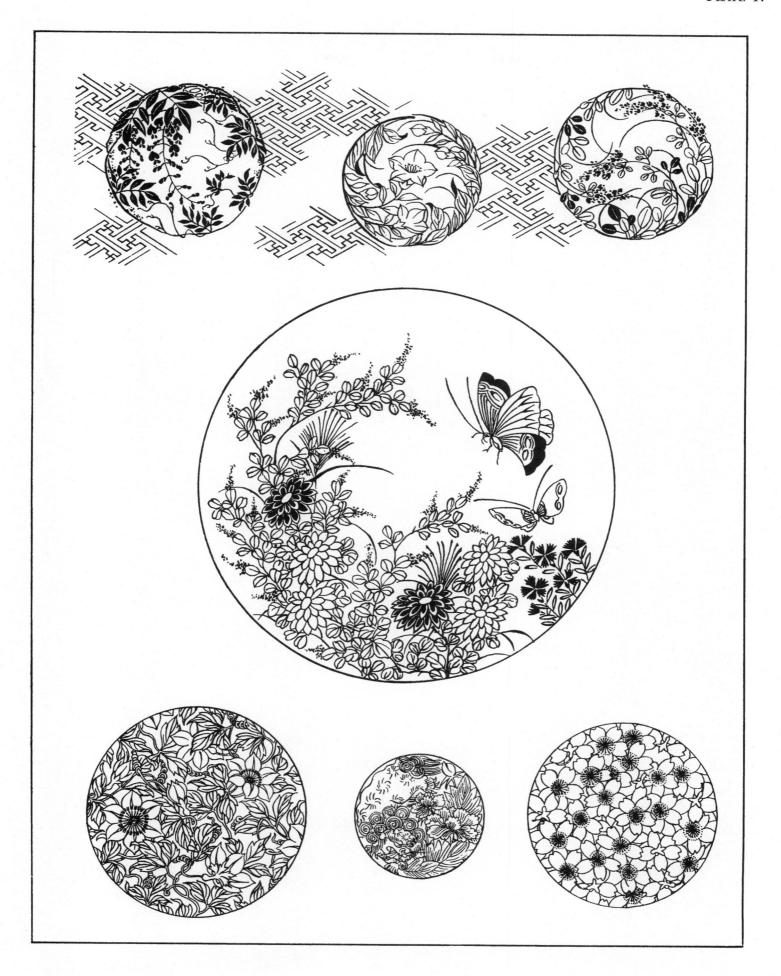

PLATE 48

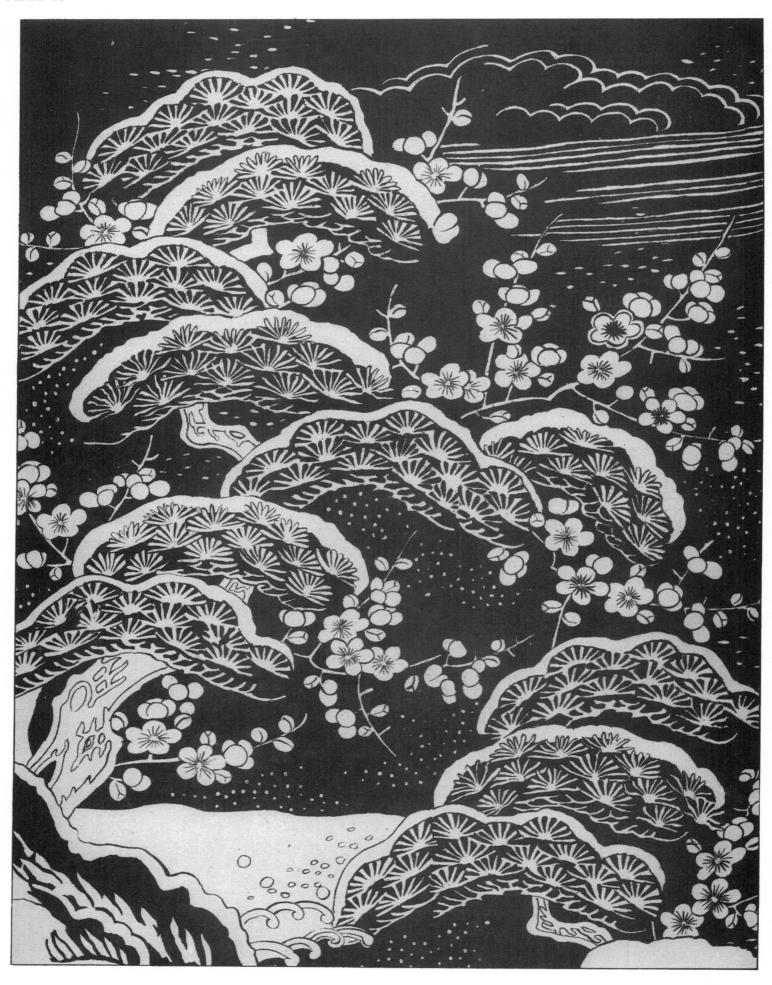

PLATE 49

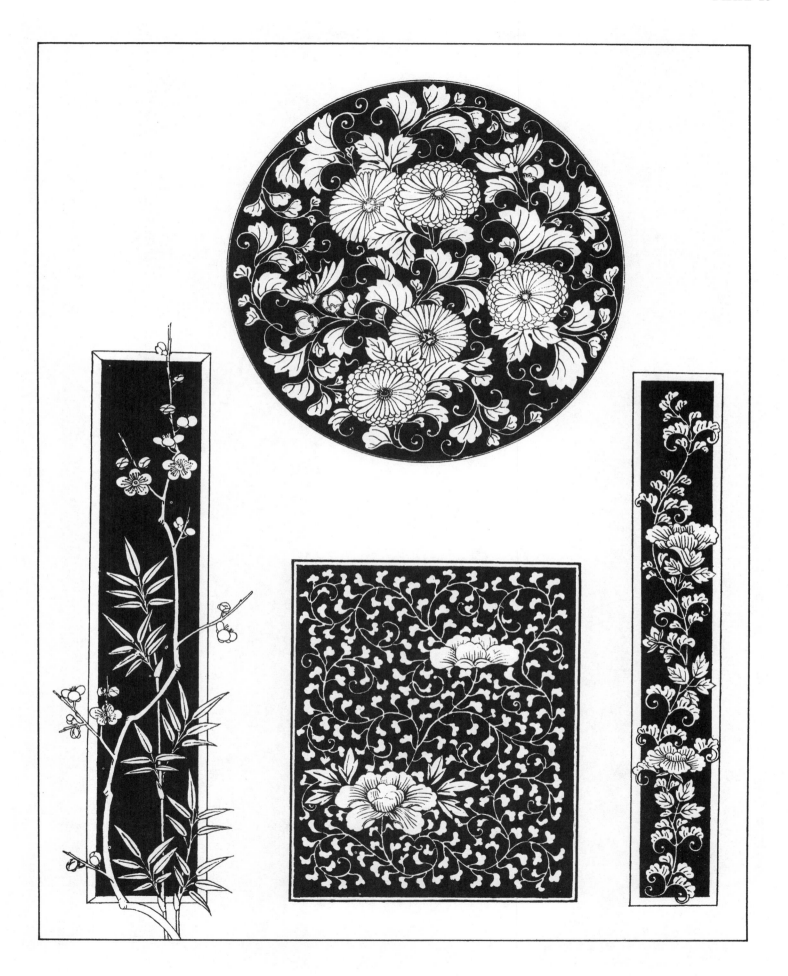

PLATE 50

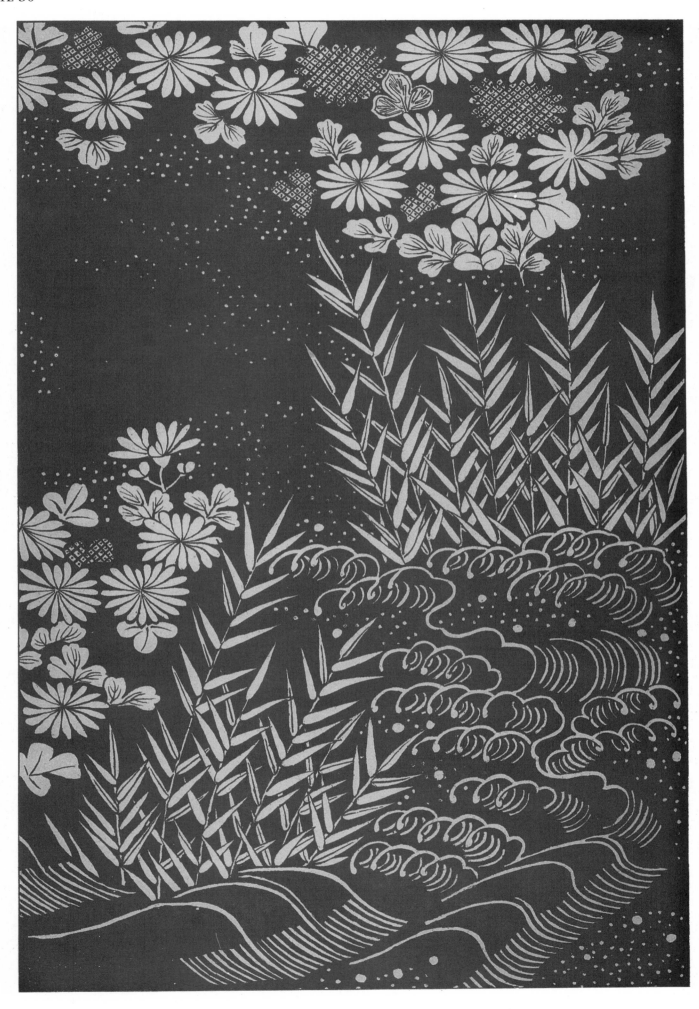

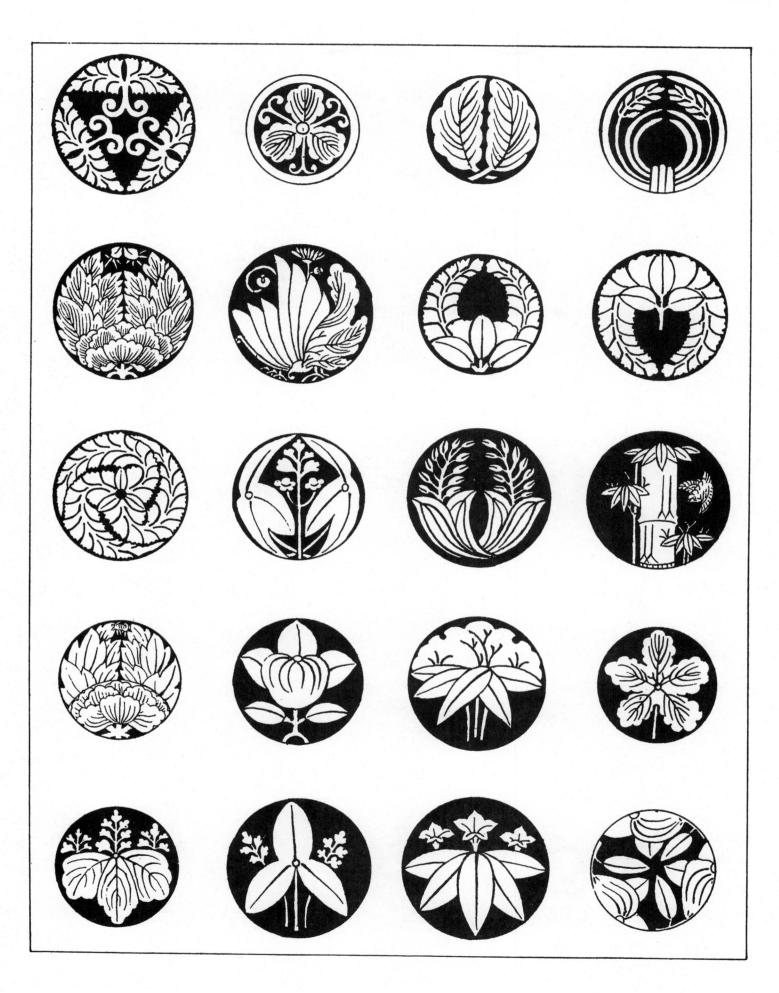

PLATE 51

PLATE 52

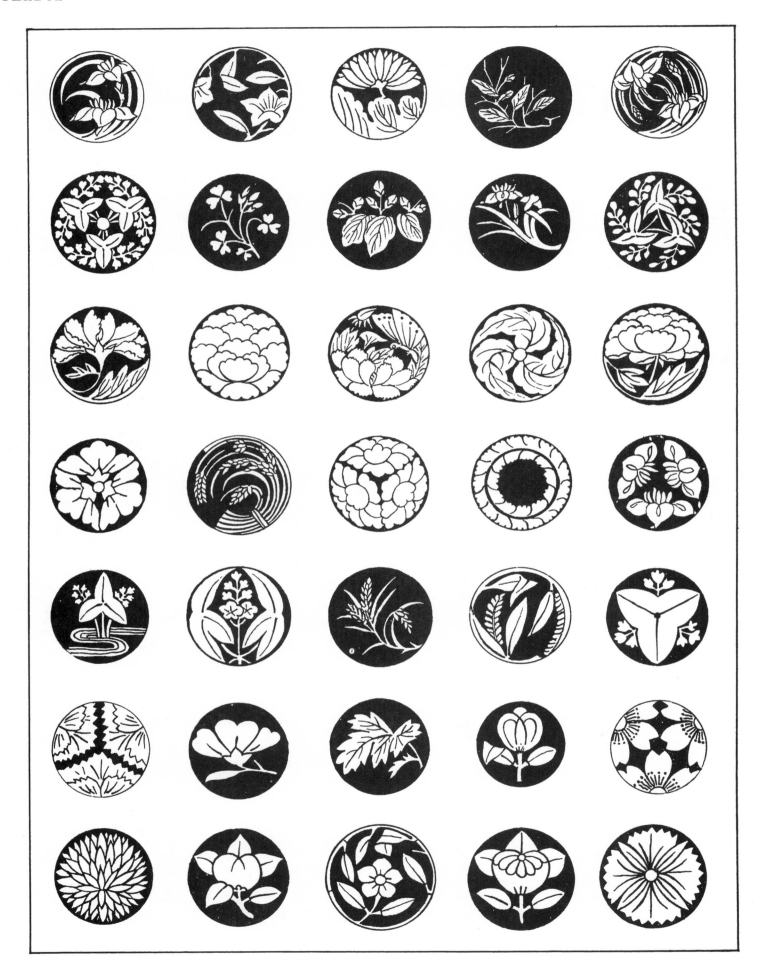

PLATE 53

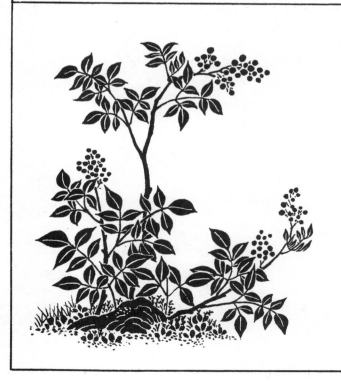
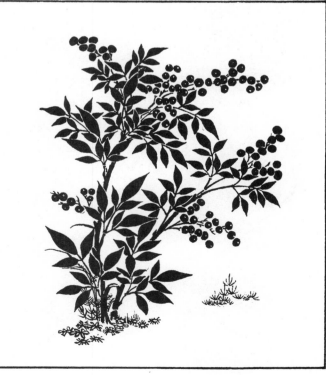

PLATE 54

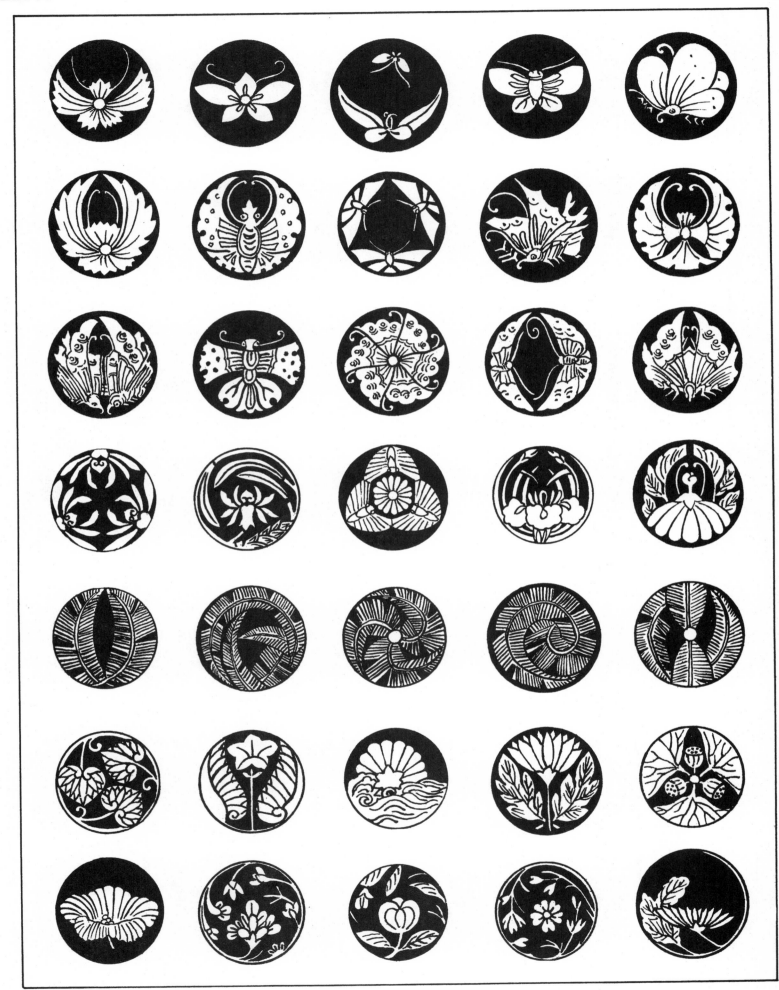

PLATE 55

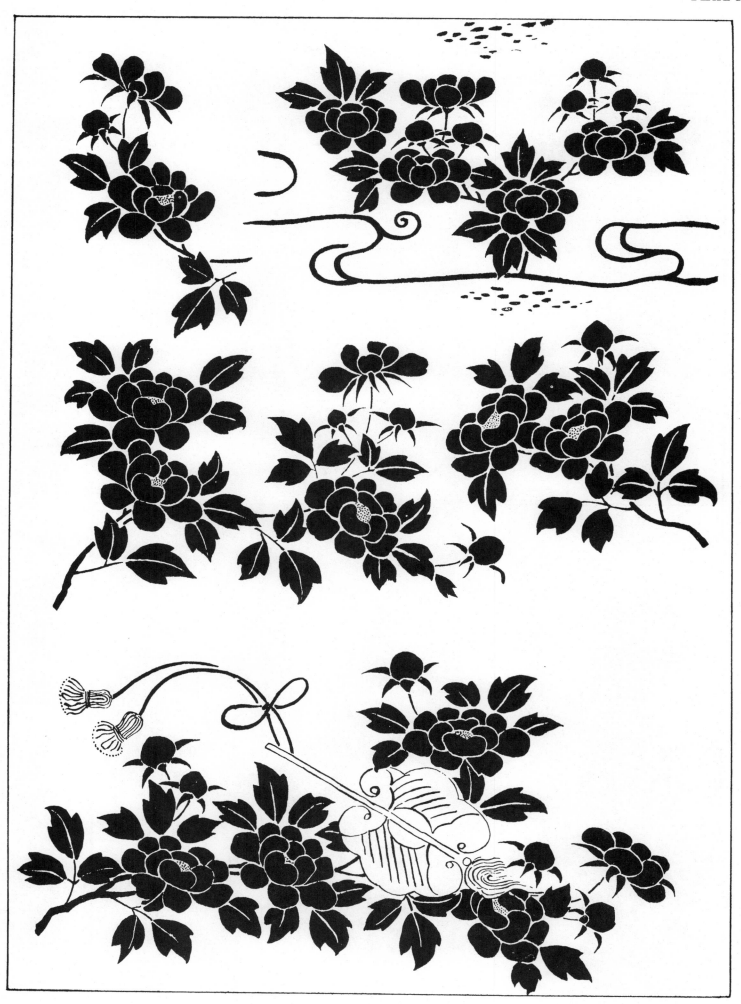

PLATE 56

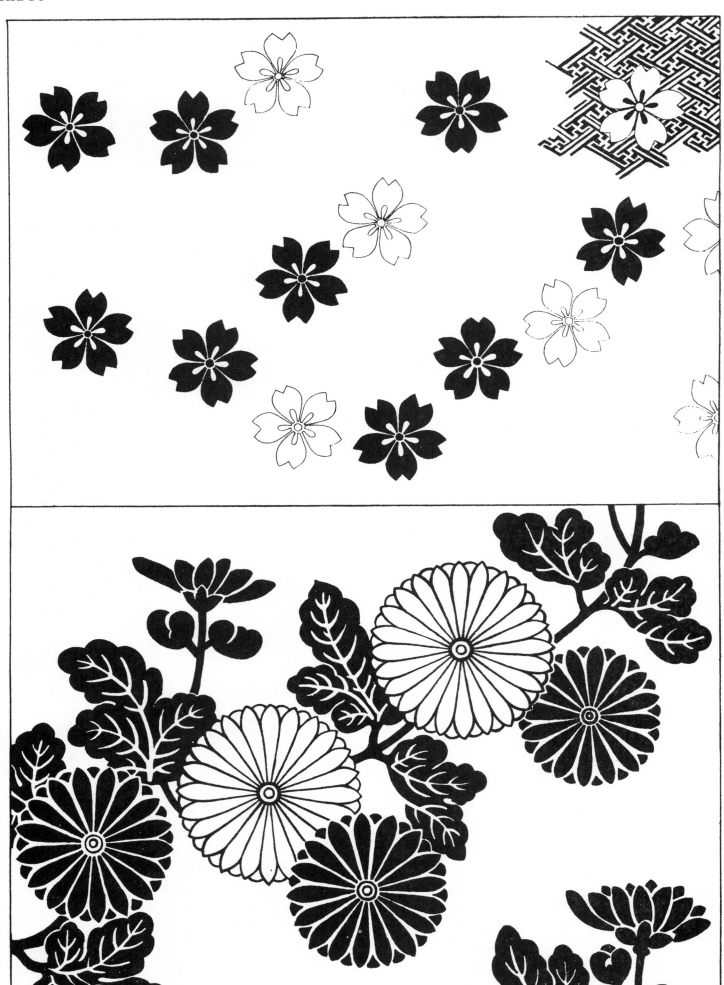

PLATE 57

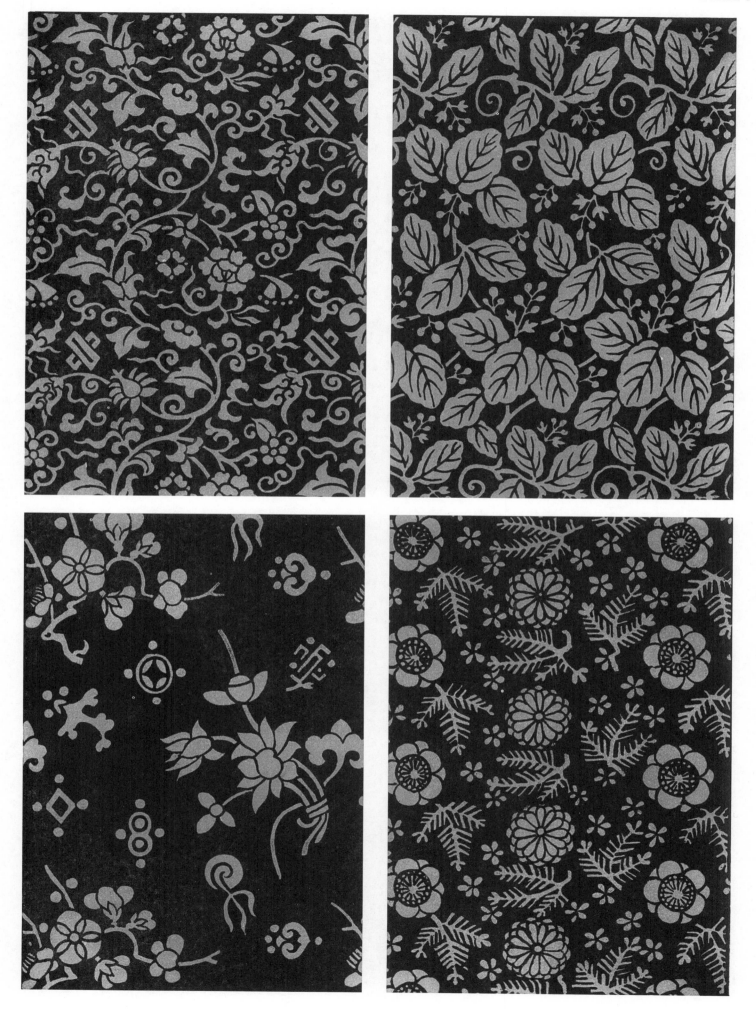

PLATE 58

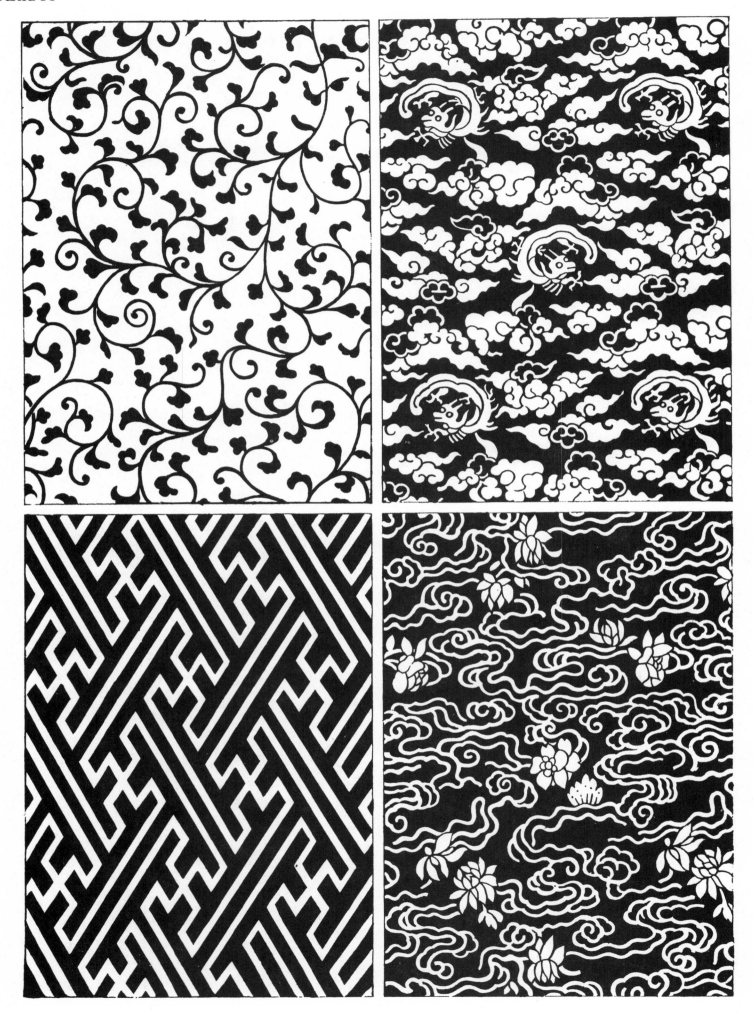